SEN. ANGUS S. KING JR.

A Senator's Eye

Celebrating Maine, Washington, and
the Joys of Scraping the Windshield

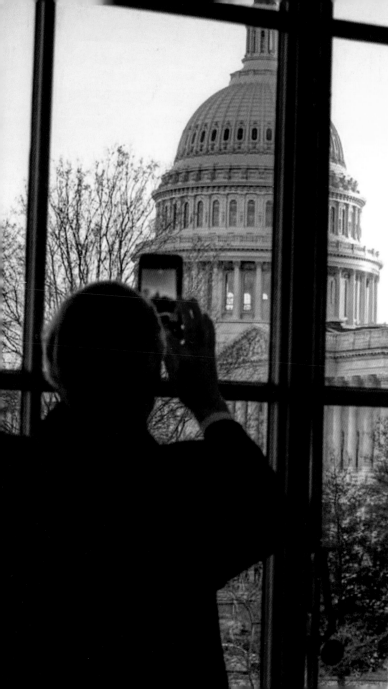

ISLANDPORT 🏛 PRESS

P.O. Box 10
247 Portland Street
Yarmouth, Maine 04096

ISBN: 978-1-944762-59-9
Library of Congress Control Number: 2018942580

Dean Lunt, Publisher
Cover and book design by Teresa Lagrange, Islandport Press
All other images courtesy of Angus S. King Jr. unless otherwise noted.

Printed in the USA by Versa Press

SEN. ANGUS S. KING JR.

A Senator's Eye

Celebrating Maine, Washington, and
the Joys of Scraping the Windshield

ISLANDPORT PRESS

Introduction by Sen. Cory A. Booker (D-New Jersey)

From the moment I met him, I knew there was something special about Angus King.

Angus was one of the first people I got to know in the Senate after I arrived in October 2013. A Senate newbie himself, sworn in just a few months before me, Angus and I quickly bonded over our mutual excitement to serve and contribute—and over our attempts to learn our way around the building.

Angus is an impressive person by any measure. An accomplished attorney and entrepreneur—not to mention a former television host and cancer survivor—he's a member of a small club of senators who first served as the governors of their respective states.

What sets Angus King apart, however, isn't the titles he's held, but rather the kind of person he is. There is a comforting honesty about his spirit. He's proudly and fiercely independent, elected to two terms as governor and to the Senate without claiming allegiance to a political party. His hopefulness is a salve to the cynicism that too often pervades politics. He relishes the history, the hidden gems and the stories of our national institutions. And he loves the people that make it all work, from his fellow senators to the young high school students who serve as pages on the Senate floor.

His plainspoken wisdom gives him the feel of an elder statesman, and refreshingly, Angus is always humble and has never lost the childlike exuberance for the opportunity he's been given to serve. To him, the Senate is just as magical, just as beautiful, just as majestic as it has ever been.

Angus, the man from Maine, still feels so blessed and grateful to serve in the United States Senate and he views everything through that lens—the lens of gratitude, keen interest and wonder.

And, fortunately for us, there's another lens through which Angus sees the world: his photography.

A dear friend, mentor and neighbor of mine from Newark's high-rise projects once told me: "The world you see outside of you is a reflection of what you have inside of you."

One of the reasons my friend and fellow Senator Angus King has a tremendous eye for photography is because he is a tremendous man. And in this book you will see for yourself Angus' truly remarkable pictures and his reflections on them.

You will see the beauty he sees, the humor, the grandeur and the hope, because he carries those things within him.

You will see the grandeur and greatness of Maine, because that is within him.

And you will see wrongs that need to be righted, injustice that must be corrected, and people who merit and deserve our love and attention because that conviction is a deep and driving part of him too.

I am blessed by my friend's eye. You will be too.

There's just one more thing you need to know about Angus King:

I'm responsible for introducing him to Instagram!

OK, maybe that's an overstatement. But I am proud that I badgered him into giving Instagram a try. We are all very fortunate that Angus has chosen to share his work with the world, both online and in the pages of this book.

I know you will enjoy it as much as I do.

Thank you, Angus.

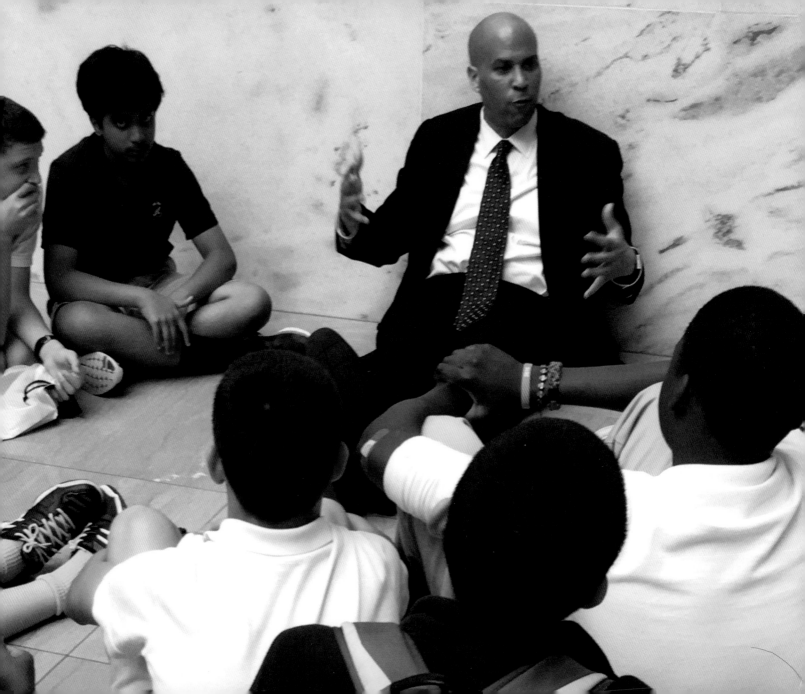

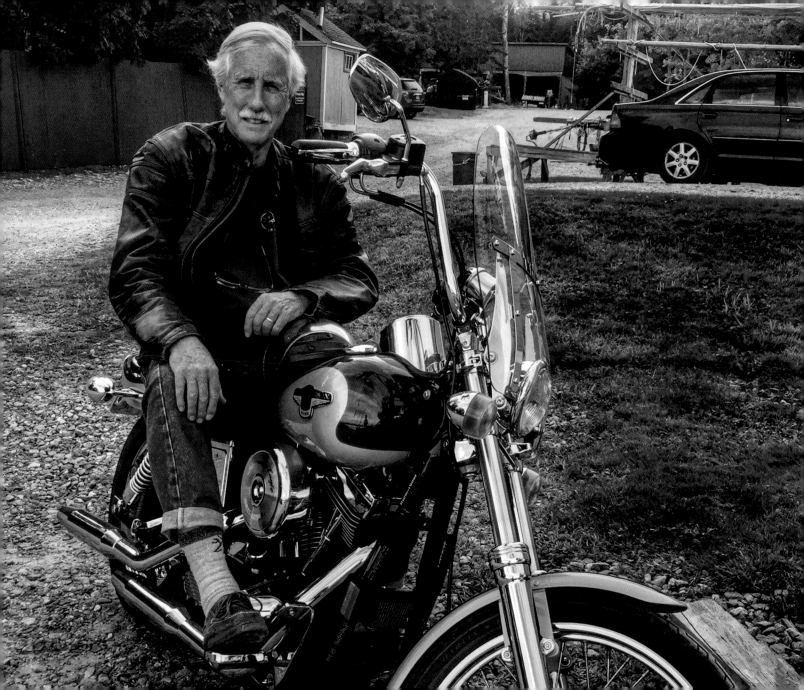

Preface

I didn't know it, but all my life, I've been waiting around for Instagram. It combines two of my favorite avocations—photography and writing—and enables a third, storytelling. And this, in turn, has given me the chance to share little slices of my somewhat unusual life with friends, family, and well, the world.

The other bit of enabling technology at work here is the camera-equipped smartphone. It used to be (in the far-off days of 2007) that we said "the camera's not great, but at least you have it with you all the time." Now, the camera is pretty great and is still always there when a cool shot presents itself.

So what I try to do once or twice a week is capture a moment, whether it's an insider's view of some corner of the Capitol, a Maine sunset or a stack of dirty dishes with a story to tell. There is no particular theme and I don't go looking for certain pictures; instead, I shoot what strikes me as beautiful (pretty easy if you live in Maine), entertaining, engaging or even occasionally inspiring.

One final note: these posts are really me—no ghost writers or staff editors. It took a while to persuade my wonderful staff in Washington that I could responsibly handle writing and posting by myself (and it still makes them nervous from time to time), but so far, they seem OK with this Senator-on-the-loose thing.

And besides, like I mentioned above, it's fun—as I hope it is for you as well. Enjoy; and don't worry, those dishes did get washed!

Angus

June, 2018

Maine Life

I've always thought the character of a place affects the character of the people, and Maine is Exhibit A. The state can be tough, with long winters, endless forests, small communities and the unforgiving ocean to the east. And so its people have been formed—tough, resilient and independent, but caring and neighborly as well.

Among the other characteristics that define Maine are a generally high level of honesty and integrity, which grow out of our history (and geography) as a state. With a relatively sparse population and, at least until recently, being somewhat isolated from the rest of the country (we generally refer to any place other than Maine as "away," as in, "he's pretty OK for someone from away"), reputation is unusually important. Put another way, when repeat business is all there is, you'd better treat people right the first time.

Once, in the midst of a committee meeting in Washington, my colleague Sen. Susan Collins was speaking, and the senator sitting next to me leaned over and whispered, "Is there something in the water in Maine that gives people common sense?"

Pretty good compliment to me and Susan, but mostly, to Maine.

Making Noise in The County

Madawaska, Maine

Sen. Susan Collins and friends at the World Acadian Congress parade. Loudest parade ever—and great fun!

August 20, 2014

The Puppy Picture
Augusta, Maine

OK, shameless politician-with-puppy picture. This little guy belongs to Tim Caverly, whom I ran into at the State of Maine Sportsman's Show in Augusta. If you get mad at me for some vote or another, just remember this image and smile!

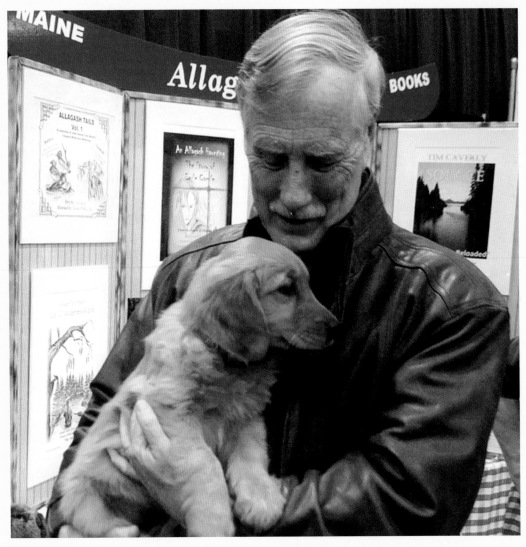

March 28, 2015

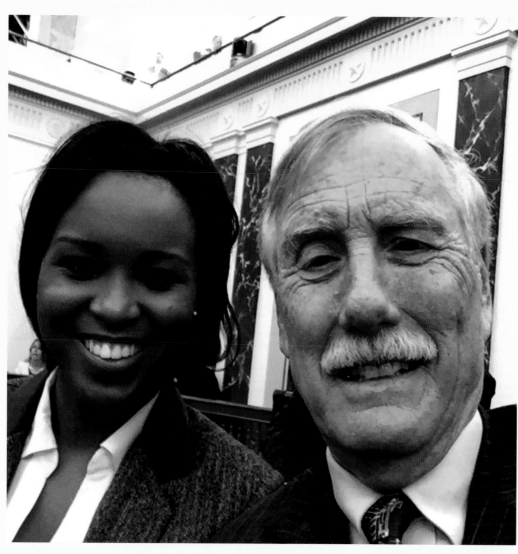

March 30, 2015

Marielle Thete
Boston, Massachusetts

At the dedication of the new Edward M. Kennedy Institute for the United States Senate in Boston—with Marielle Thete of Portland, who's one of the student senators participating in the ceremony. Marielle came to Portland at the age of six as a refugee from the violence which was then engulfing the Congo, her home country. She learned English, finished high school in Portland and is now a student at Wheaton College. The Kennedy Institute features a full-scale replica of the Senate chamber, where we grabbed this selfie. The center is supposed to inspire them, but it's more likely that they will inspire us!

Note: Marielle now works in my Washington office as my state scheduler—in other words, she's the one who regularly tells me where to go!

Susan and the Harley

Bath, Maine

OK, this is pretty funny. This afternoon, Sen. Susan Collins and I met with some guys at Bath Iron Works and Rob Jacobs (the same guy I once took a photograph with standing behind his Harley) was there with this wonderful blanket. A friend of Rob's snapped the picture last summer and had it blown up on the blanket—very cool. I think Rob was a little nervous, but Susan loved it. Even U.S. senators get a laugh every now and then!

June 9, 2015

Lacrosse, Hot Dogs and Championships

Brunswick, Maine

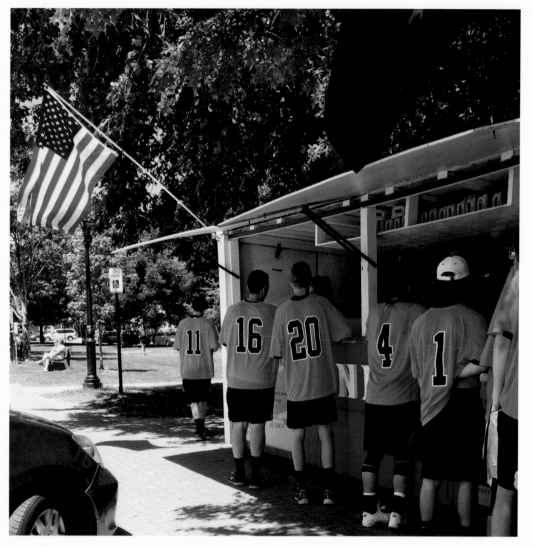

This picture tells a great story. I live in Brunswick and the Brunswick High School boys lacrosse team just won the Maine Class A state championship in a hard-fought game against South Portland (who beat us last year) and are enjoying hot dogs on the mall along with parents, friends, schoolmates and just plain fans like me and my wife Mary. Fire trucks and floats led the team back into town amidst horn-blowing, cheers and more than a few tears. One dad surveyed the scene and pronounced that it just doesn't get any better than this. I completely agree.

June 20, 2015

Time to Recover

Boston, Massachusetts

Mary and I twenty-four hours after my surgery for prostate cancer and feeling much better—a little sore around the middle and cobwebby in the head (so what else is news you say?) but actually feel pretty well. There's not a lot good about an experience like this, but feeling so much love from so many friends has been absolutely overwhelming. Now all I need is a week in Maine!

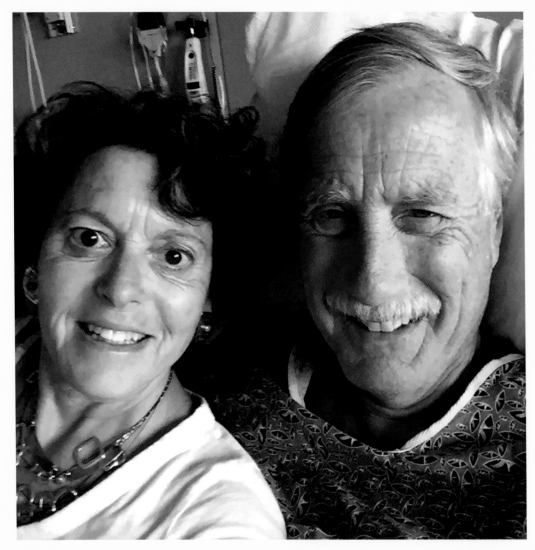

June 27, 2015

June 29, 2015

Road to Recovery

*On Interstate 95,
New Hampshire*

I've never been so glad to see this sign! Feeling pretty OK (after surgery to treat prostate cancer) and looking forward to a week in Maine. Mary has been fantastic, by the way, which will surprise no one who knows her.

Independence Day Tradition

Bath, Maine

I felt like a little walk this morning—and what better place than the Bath Heritage Days parade! It was great to see so many old friends. I probably should have ridden, but felt good and decided to march. Made it in good shape, along with my friends from the crew of the *USS Zumwalt*, currently under construction at Bath Iron Works. Mary marched with me and took this nice shot on the fly. Happy Fourth!

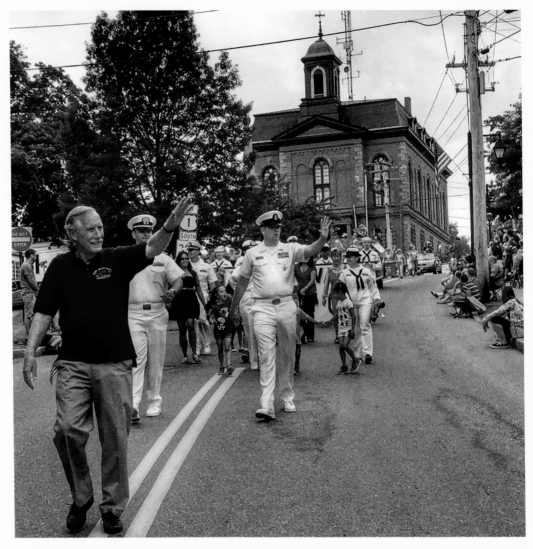

July 4, 2015

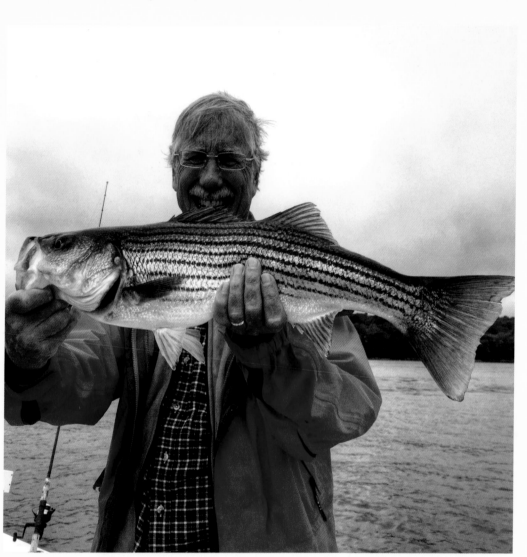

August 25, 2015

Striper!

Kennebec River, Maine

Fishing on the Kennebec with two of my sons—who taught me that if you extend your arms slightly, the fish looks bigger! We think he was a keeper, but we released him anyway. This may look like fun, but I was actually doing research on the flora and fauna of the river. Yeah, sure.

World War II Veterans

Portland International Jetport,
Portland, Maine

Incredibly powerful experience this morning as a huge crowd turned out to welcome a group of World War II veterans home from an Honor Flight to Washington. These weekend trips from all over the country are a wonderful idea to honor the Greatest Generation and include visits to the World War II Memorial (where this group met former Senate Majority Leader Bob Dole!) and other sites in Washington. There literally wasn't a dry eye in the house, especially among the veterans.

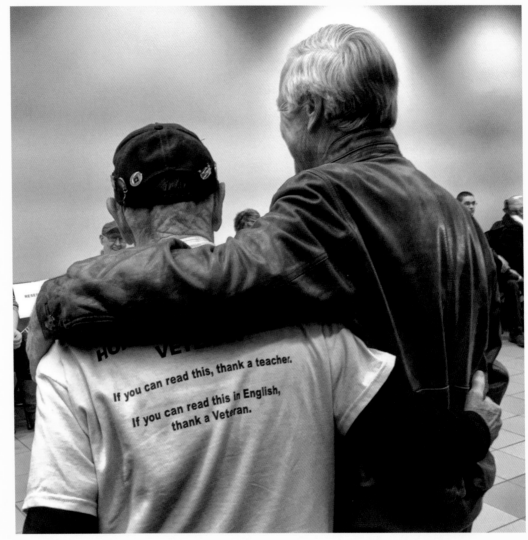

November 1, 2015

I Can Shovel, Too!

Brunswick, Maine

I'll admit it—I'm posting this just to show people that both Maine senators know how to shovel snow. In case you missed it (and practically no one did), my colleague Sen. Susan Collins received a big dose of national publicity last week with a picture of her shoveling out from the great Washington snowstorm of '16. I may be late to this shoveling party, but at least I'm working with superior quality Maine snow!

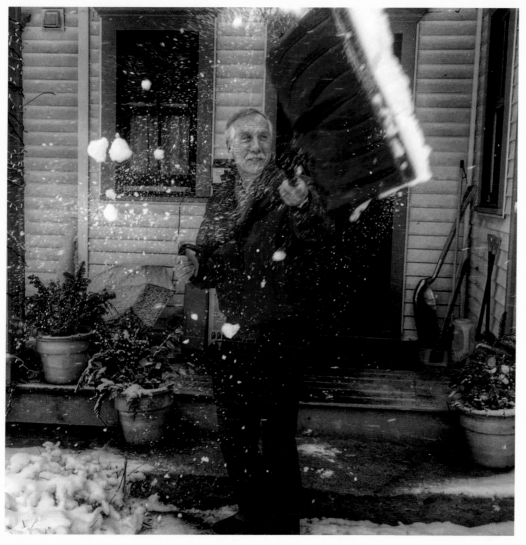

February 5, 2016

Easter Sunrise

Sugarloaf Mountain,
Carrabassett Valley, Maine

An Easter congregation on the mountain-side, which I'm told numbered more than 500. Normally, I wouldn't think of taking a picture in church, but this seemed OK. It was a very moving experience to share this moment surrounded by so much beauty. (No, the guy in the foreground isn't me, but he does have a nice-looking 'stache).

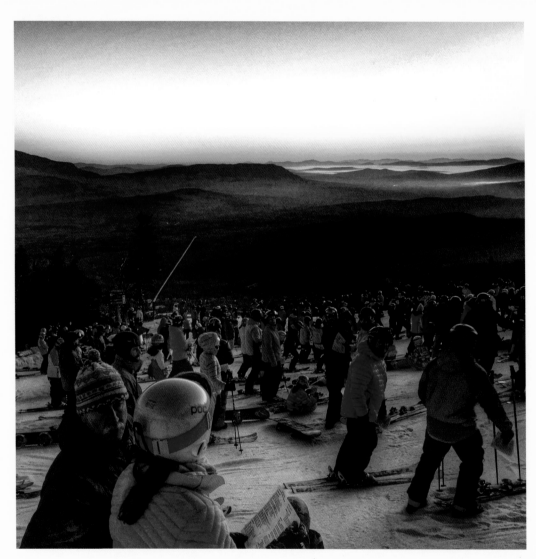

March 27, 2016

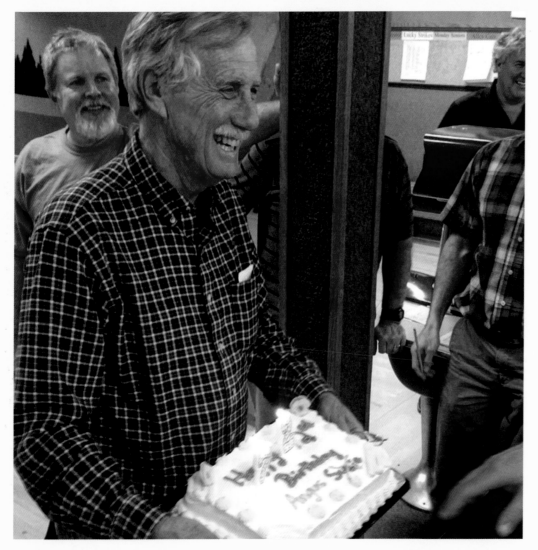

March 31, 2016

Happy Birthday, Senator!

Brunswick, Maine

What better place to celebrate a birthday than the bowling alley? A night of candlepins with some pals from around Brunswick—capped off with a surprise cake. My friend Brian got a deal on the cake; it said "Happy Birthday Susie" so he had them cross out Susie and put in Angus. But it's the thought that counts, right?

Young Man and the Sea

*Five Islands,
Georgetown, Maine*

There was big excitement on Sunday evening at the Five Islands wharf. Adam Armstrong brought ashore this amazing tuna he caught on rod and reel off Boothbay. He fought the fish for more than two hours, and ended up in the water at one point, trying to get it aboard the fishing boat. Here, it's being wrestled ashore and into a truck full of ice for transport to market. *Young Man and the Sea* might be a good book title, eh? And by the way, this isn't sport for Adam, it's part of how he makes his living—that fish represents a week's pay.

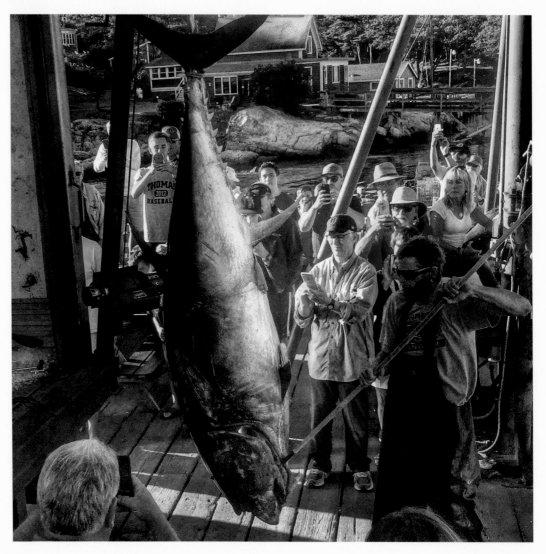

August 1, 2017

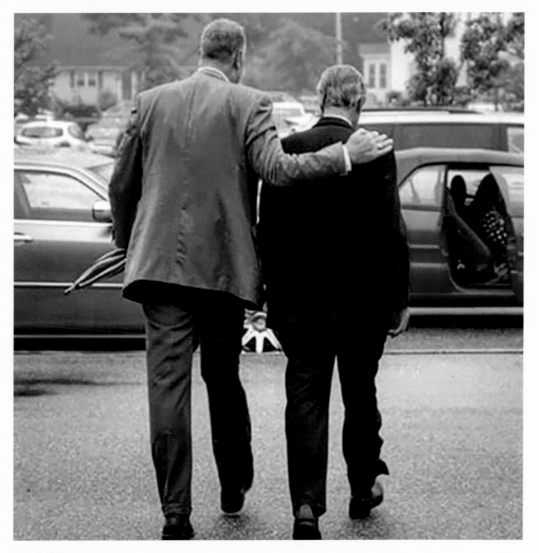

Big Guy, Big Heart
Saco, Maine

Jim Trask is one of my best friends from my days as governor. He was part of my security detail, and we covered a lot of miles together—from Portage Lake to Kittery, in cars, trucks and yes, on motorcycles. Our families have remained close ever since those days. Here, we are leaving Thornton Academy this past Sunday after graduation, and this shot really captures our ongoing friendship. You can see that he's a big guy; I can tell you that he has a big heart, as well.

June 7, 2016

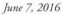

Smoking Ribs
Washington, D.C.

It's time to admit that as much as I like serving in the Senate, I'm really in my element smoking ribs. These beauties came out really well (he said modestly) after four and a half hours at 255 degrees and featuring my friend Doug Kaplan's homemade rub. The smoke is provided by ground-up Jack Daniel's barrels. A tasty end to a beautiful Fourth!

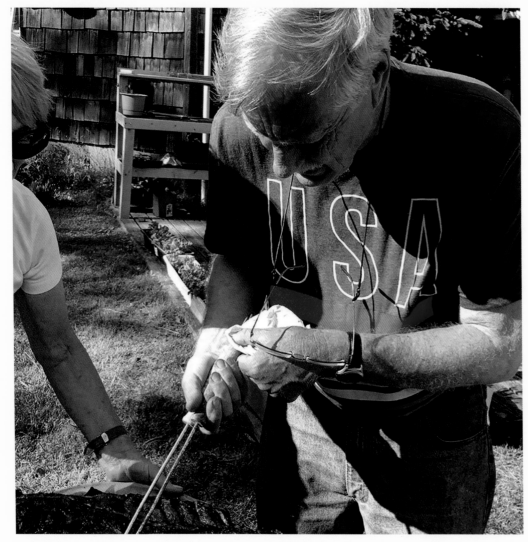

July 4, 2016

The Rainbows of Aroostook County

Mapleton, Maine

These rainbows are real, honest. It's a Mapleton Lions vs. Doyen's Farm, 12 and under Little League game. A storm went right around us, producing this scene. What a way to spend a summer evening!

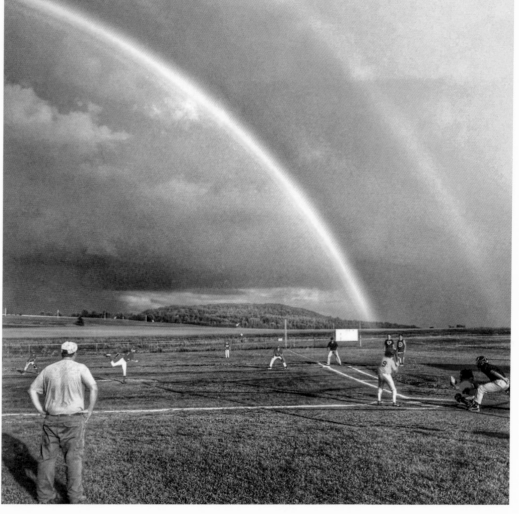

July 26, 2016

The Power of a Local Church

Caribou, Maine

Gray Memorial United Methodist Church in Caribou. Every Maine town has one or more of these beautiful old churches, most dating to the late 19th and early 20th centuries. I often think of what they represent—the faith, optimism, imagination and commitment of the local people. The farmers and woodsmen who conceived and built this magnificent structure were all about their community, not only in a religious sense, but also in the larger sense of pride of place.

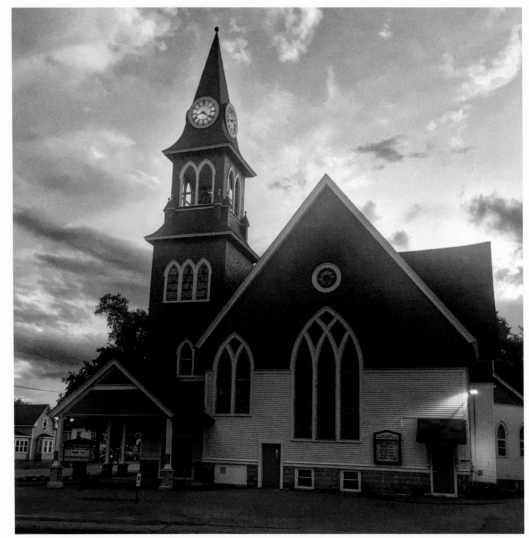

July 29, 2016

Maine Aquaculture
Damariscotta, Maine

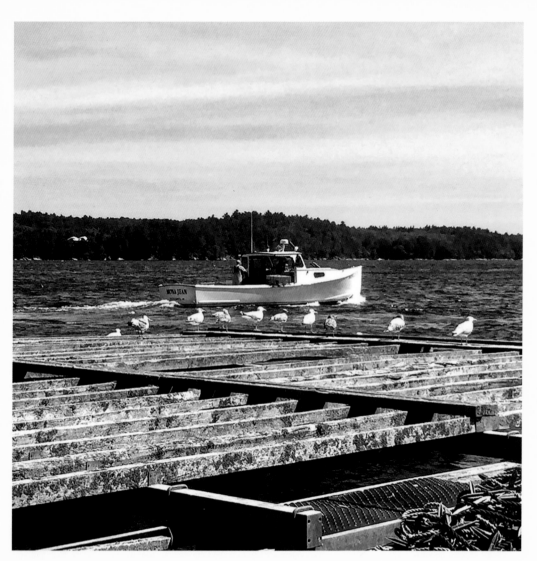

August 6, 2016

Aquaculture in Maine is now a $150 million-a-year business—creating new jobs all along the coast. It all started in this little cove on the Damariscotta River about 40 years ago. The raft in the foreground has ropes underneath with mussels, seaweed and even an experimental crop of scallops. In the background, of course, under the watchful eyes of a flock of gulls, is a good old lobster boat. What was really impressive after a day on the river was the enthusiasm, creativity and pride of a new generation of water-borne entrepreneurs who are literally inventing new industries, not to replace, but to complement the old. And, at the end of the day, the fresh oysters were the best.

Maine's Western Mountains

Carrabassett Valley, Maine

Truth in advertising—we weren't actually mountain biking, but we did run into our old friend Lloyd Cutler (of Gepetto's at Sugarloaf) who was out for an afternoon ride while we were hiking the Narrow Gauge trail. Lloyd took this nice shot, which somehow captures the truly spectacular week we've had in Maine's western mountains—snug nights in the RV, unbelievable scenery and warm visits with old friends. Nice bike, Lloyd!

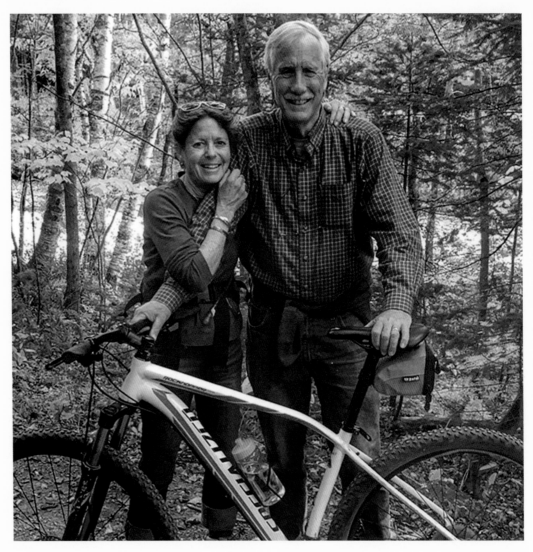

October 8, 2016

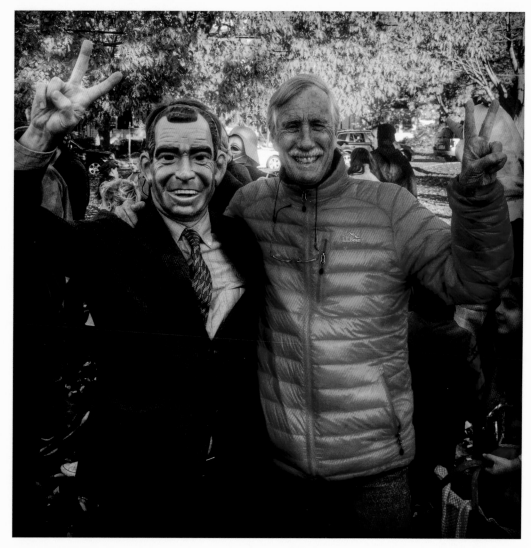

October 31, 2016

Four More Years!

Brunswick Mall, Brunswick, Maine

Well, you never know who you'll run into at the Brunswick Recreation Department Halloween costume parade! Here's old Richard Nixon (He doesn't look all that bad in retrospect, does he?) still giving his famous victory sign. Actually, behind the mask is neighbor Ben Tucker, who claimed he marched in the parade wearing the same mask more than 20 years ago. The parade was fabulous—creative and funny costumes, excited kids, the high school band, and just a great community feel. My costume? Isn't it obvious? U.S. senator on a day off!

Classic Vinyl

Brunswick, Maine

I was looking for something in the basement and came across a big plastic bin of old 33 RPM records, which naturally sent me to the attic looking for an ancient pair of Infinity speakers (my proudest possessions, circa 1978), which then sent me to Vinylhaven Records in downtown Brunswick for a suitable turntable. To my delight, Dave Hunt had this beauty, a vintage KLH 24, very close to the KLH 20 that originally powered my speakers. So now, I've got a wonderful new (old, actually) setup, playing the likes of Dave Mallett, the Dead, Dionne Warwick and Jimmy Buffett. And as a bonus, at the bottom of the record bin was an original Whole Earth Catalog! It don't get much better than Dave Mallett on vinyl and a sandwich of leftover turkey from Thanksgiving.

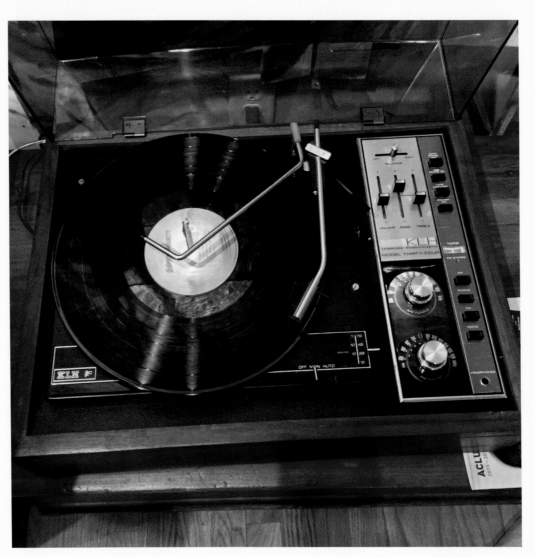

November 25, 2016

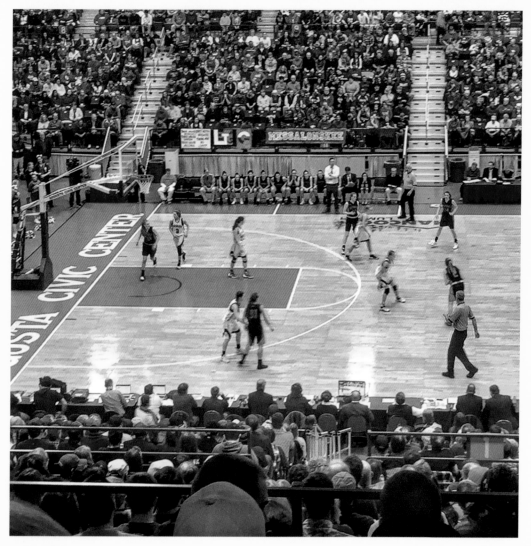

March 5, 2017

States!

Augusta, Maine

Absolutely packed house Saturday afternoon at the Augusta Civic Center for the Class A state championship basketball game between the Brunswick Lady Dragons and the undefeated Eagles of Messalonskee. The Eagles won handily, but both teams fought hard and didn't quit. It was great to see the wonderful community spirit behind both teams and fun to be part of this special Maine tradition. Congratulations to all—the exceptional players, the Maine Principals Association, which sponsors the tournament, and the always supportive parents and fans.

Cheers!

Brunswick, Maine

Cheers! This image is from the grand opening of the very cool Flight Deck Brewing at Brunswick Landing (formerly Brunswick Naval Air Station). My toast was to Flight Deck and its wonderful crew and to the State of Maine on the day after its 197th birthday. Microbrewing in Maine is an amazing story—in 2011 there were about 35 breweries in Maine, but now there are 90 and rising, employing more than a thousand people. What's really cool is that this explosive growth has started to create other businesses (and jobs) like malthouses and locally grown grains. Brunswick Landing is a good-news story, as well, now with more than 2,000 jobs and 80 percent of the payroll compared to when the base closed. Here's looking at you, kid!

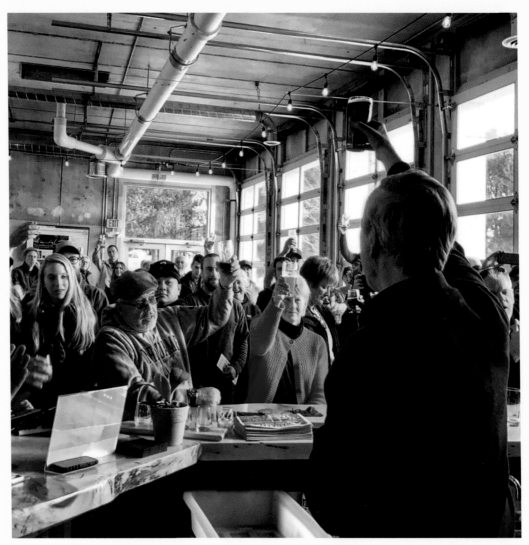

March 17, 2017

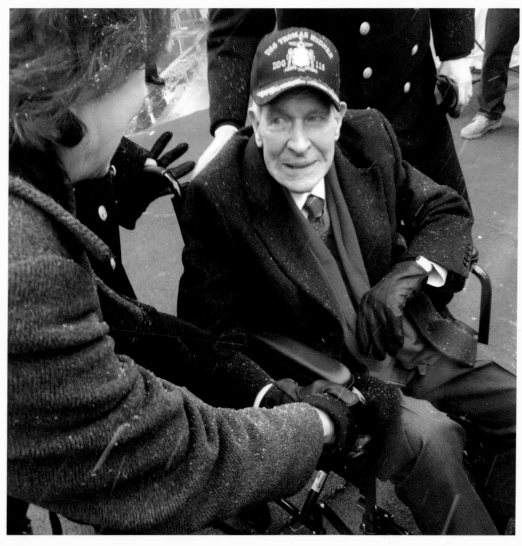

April 1, 2017

An American Hero
Bath Iron Works, Bath, Maine

This is a true American hero, Capt. Tom Hudner, being congratulated today by my colleague Sen. Susan Collins. Capt. Hudner is a Congressional Medal of Honor recipient and namesake of the new ship christened Saturday morning at Bath Iron Works. When his wingman (Jesse L. Brown, the first African-American naval aviator) went down near the Chosin Reservoir in Korea in the winter of 1950, then-lieutenant Hudner crash-landed his own plane to come to the aid of his shipmate. After all the speeches, it was the determination and dignity you see reflected in his face that most moved me.

Update: Capt. Thomas J. Hudner Jr. died on November 13, 2017.

Moooooo!

Clinton, Maine

This shot cries out for a caption contest, so have at it—but be nice to the cow. She's at Flood's Brothers Farm in Clinton (just north of Waterville). What struck me was the complexity of the operation—from feed to healthcare (for the cows) to automated milking machines and computers that track the health and well-being of each cow. It's always fun to see where the products we take for granted come from —and how much thought and care goes into the process. (Great photo by Jenni Tilton-Flood).

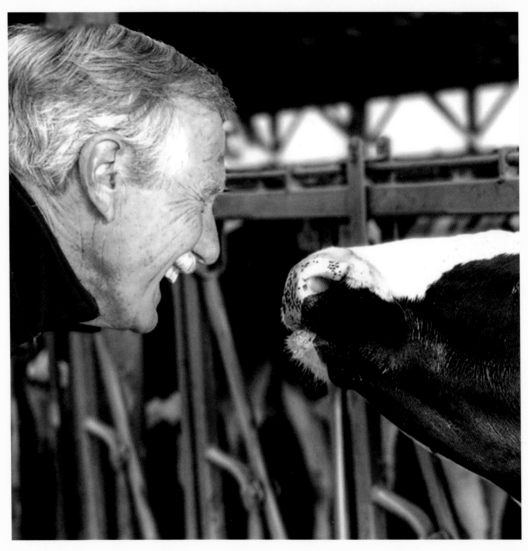

May 26, 2017

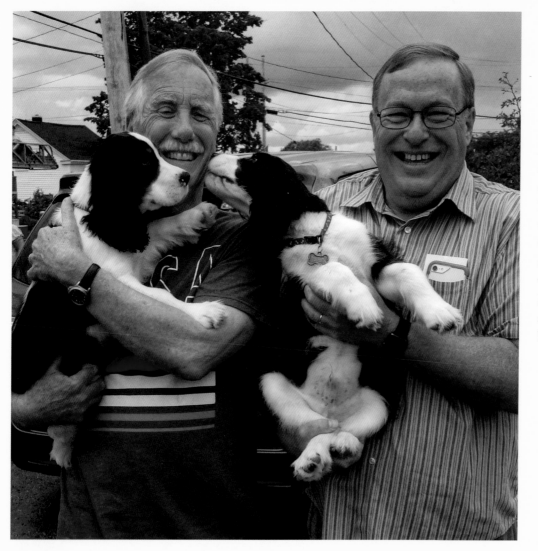

July 5, 2017

Puppy Power
Eastport, Maine

The Raye's Mustard mascots helped me get ready for the Fourth of July parade in Eastport. Kevin Raye is an old friend who served with me in Augusta—and when he came over with these little guys, well, you can see what a terrible time we were having. The parade was amazing—thousands of people along the route, giant trucks, a bagpipe band, color guards, and the highlight, sailors from the *USS Lassen*, which was docked at the brand new Eastport breakwater. Fireworks, families and old friends—it doesn't get much better.

Andre the Seal

Rockport, Maine

Selfie with a seal! For those of you "from away" (that's anyone who's not a third- or fourth-generation Mainer), Andre the Seal is a legendary Maine character. Born in Rockport Harbor in the '60s and befriended by harbor master Harry Goodridge, Andre was a fixture in the area for 25 years. He spent his winters at the New England Aquarium in Boston and was then released each spring to make his way up the coast to Rockport. I've always thought of him as a perfect Mainer—resourceful, loyal, persistent, tough and damned smart. We miss you, man (er, seal)!

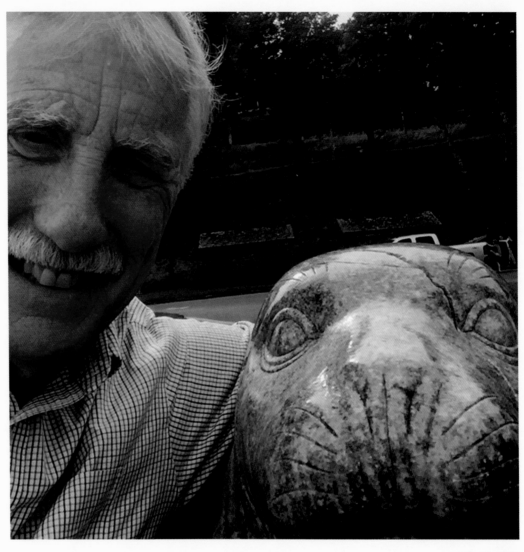

July 14, 2017

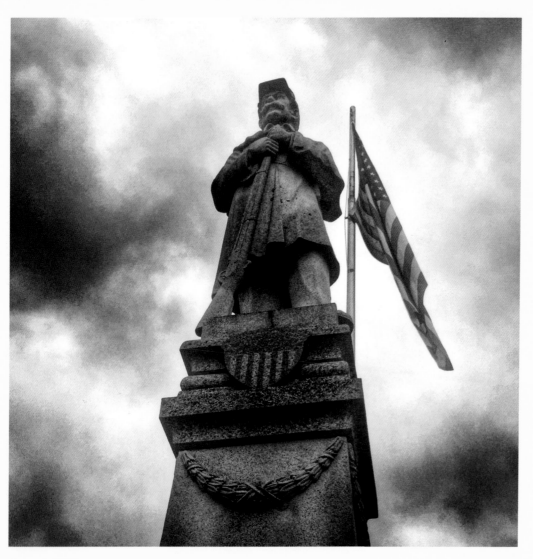

Silent Sentinels to Sacrifice

Wilton, Maine

In small towns across the eastern part of the country stand hundreds of Civil War memorials—like this one in Wilton, Maine. Although I have seen variations, the soldiers generally face in the direction of their loyalties—in the South, they face south and the opposite way in the North. It's hard for us to appreciate this war's devastation and loss. In Maine, for example, 59 percent of the men between 18 and 45 served in the Union Army—and in some of the early battles, nearly all of the young men of a small town could be lost. These memorials, with long-forgotten names inscribed at the base, are silent sentinels reminding us of sacrifices made and promises kept.

August 5, 2017

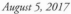

DCHOG

Kingfield, Maine

Reunion Ride, Day 2, taking a break at Mount Abram just west and south of Kingfield. We took all back roads through Weld, Carthage, Rumford, Bethel, Oxford Hills (come to think of it, there are only back roads between those towns) and stopped for the night in Otisfield where my friend Gary Crocker did his Maine humor thing at the Bell Hill Meetinghouse. I introduced him—which I've been preparing for 20 years. By the way, the license plate on that bike reads DCHOG.

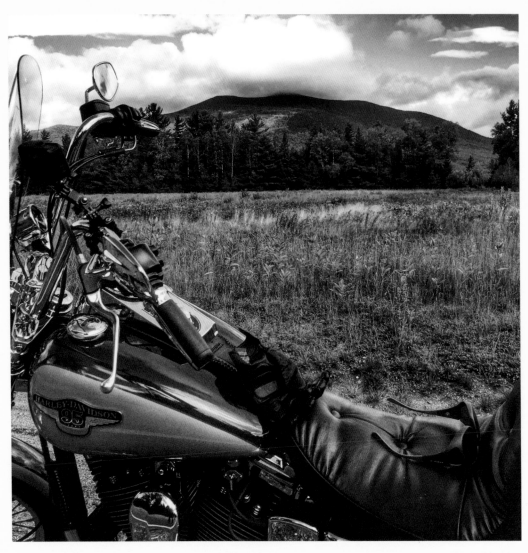

August 20, 2017

We Want a Lobster Emoji!

Islesboro, Maine

The Maine lobster industry is on a roll. It brings more than half a billion dollars (that's with a "b") into the state each year, supports families up and down the coast and is part of what induces millions of visitors to claw their way through southern New England traffic to get up here every summer. So why is there no lobster emoji? This week, I set out to correct this obvious oversight and wrote to the Unicode Consortium (the folks in charge of creating emojis) asking them to get our local crustacean on the menu. (Maybe it would help if I buttered them up). In fact, lobsters are so important to Maine, it makes me downright 🦀-by that there's #nolobsteremoji. Yet.

Update: In 2018 the Unicode Consortium announced a lobster emoji would soon be available!

September 22, 2017

Ready for Launch

Rumford, Maine

"Did I make a wrong turn?" Actually, this is a truck unloading wood chips at the Catalyst Paper mill in Rumford. It's a little unnerving to see the entire truck rise into the air, but this makes for a pretty efficient way to empty the trailer. And yes, the driver stays on the ground!

October 12, 2017

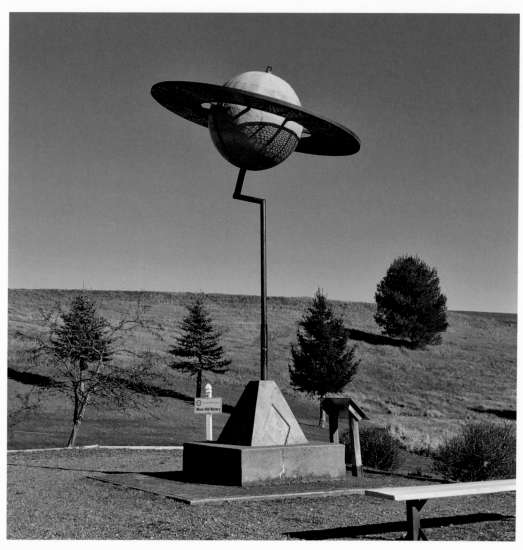

November 11, 2017

Maine Solar System
Mars Hills, Maine

Why is Saturn on the side of Route 1 in Mars Hill, Maine? Because it's part of a really cool project that graphically demonstrates the size and proportions of our solar system. The Sun is on the University of Maine at Presque Isle campus and each of the planets is set along Route 1 south toward Houlton, placed at the appropriate distance according to the actual alignment of the planets. Built by local high and technical school students under the supervision of the science department at the university, the system is built to a 1-to-93,000,000 scale. How many of us get to drive from Earth to Mars in a matter of minutes?

Flashback to Future Mayor

Augusta, Maine

This is me in the governor's office with the Mayor of Belfast—20 years ago! Samantha Paradis is now a nurse at Waldo County General Hospital and was just elected mayor after knocking on 2,500 doors. But when this picture was taken, she was a second-grader in St. Agatha in the St. John Valley, a cousin of my old friends Judy and Ross Paradis. Maine really is a big small town (with very long streets) and it's connections like this, which reach across generations, that make it so special. I can't remember what we were looking at, but it sure seems interesting. The amazing thing is that while Samantha has grown up, I haven't aged a bit. Yeah, right.

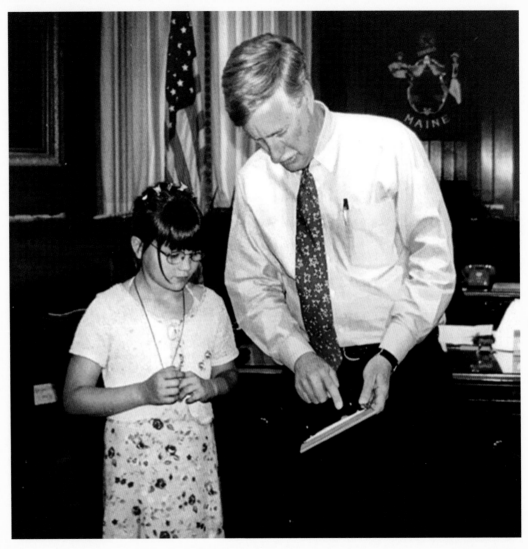

November 21, 2017

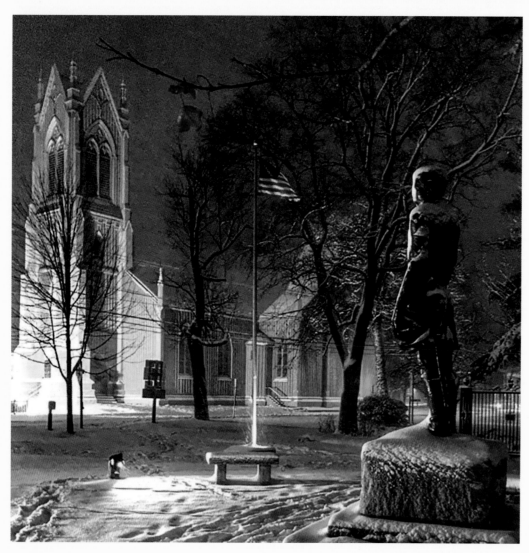

December 9, 2017

We All Need Heroes
Brunswick, Maine

Joshua Lawrence Chamberlain is the greatest citizen Maine has yet produced. Here, he stands guard in Brunswick as the first snow quietly steals up the coast. A man of immense courage, indomitable spirit and towering intellect (he spoke 10 languages), Chamberlain left an indelible mark on our state—and, with his heroics at Gettysburg, on the nation as well. First Parish Church, lighted in the background, has seen its share of history as well—including parishioner Harriet Beecher Stowe in the 1850s and guest preacher Martin Luther King Jr. a little more than 100 years later. We all need heroes; the old General is mine.

Oh, Christmas Traps
Rockland, Maine

There's a deep symbolic meaning in this Christmas tree, glowing in the early morning on the Rockland waterfront and visible on the wide bay beyond—the tree is made entirely of lobster traps! Contributing to one of Maine's iconic industries (half a billion dollars into the economy and thousands of jobs), those who fish for lobsters in many ways define the Maine character—tough, hard-working, independent, resilient, proudly defiant of both weather and the unforgiving sea and, as I can attest, distrustful of politicians.

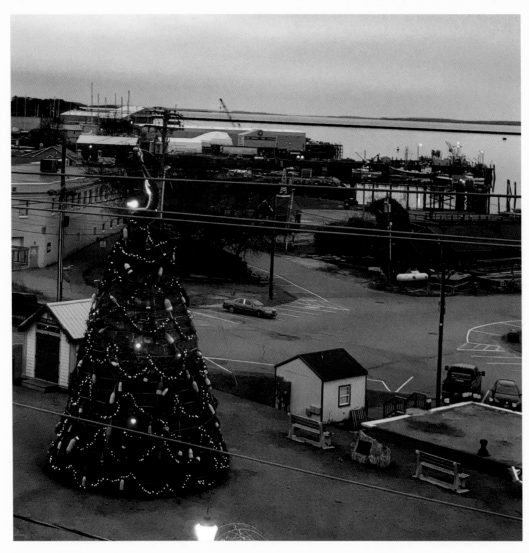

December 9, 2017

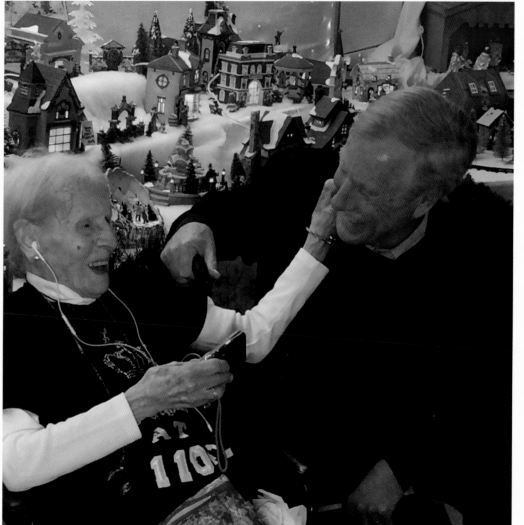

The Secret of a Long Life? Attitude.

Freeport, Maine

Meet Dorris (that's Dorris with two r's, she informed me) Farrar, born in Bar Harbor, Maine, in 1906. That's right, she's 111 years old and is Maine's oldest citizen! Wow—she was alive at the same time as Joshua Lawrence Chamberlain (who died in 1914) and President Teddy Roosevelt. She was six when the *Titanic* sank, lived through two world wars, the Great Depression, the Beatles, the moon landing and the invention of Saran Wrap. She is spry and obviously enjoys life (can you tell?). For her 110th birthday, for example, she asked for—and got—a personal video message from Tom Brady. I brought her a flag that has flown over the U.S. Capitol, complete with a fancy looking certificate which, unfortunately, spelled Dorris with only one r (I fixed it by hand). When asked the secret of her long life, she had one word—attitude, and I think she's right. There are definitely some cool parts to my job, but this visit was one of the best.

December 15, 2017

Update: Dorris passed away on April 7, 2018, 60 days shy of her 112th birthday; a full life, indeed.

Scraping
the Windshield

Maine Turnpike, Maine

Another picture in the Glamorous Life of a U.S. Senator series. Today I'm cleaning the windshield on the side of the Maine Turnpike. It doesn't get much worse than 32 degrees Fahrenheit and rain—on top of a couple of inches of fresh snow. It was just cold enough for the wipers to ice up, but not quite cold enough for snow. Made for slow driving, but we made it. When I grumbled, Mary (who took this shot), suggested I look at my driver's license, and of course, it says Maine, not Arizona. Thank goodness!

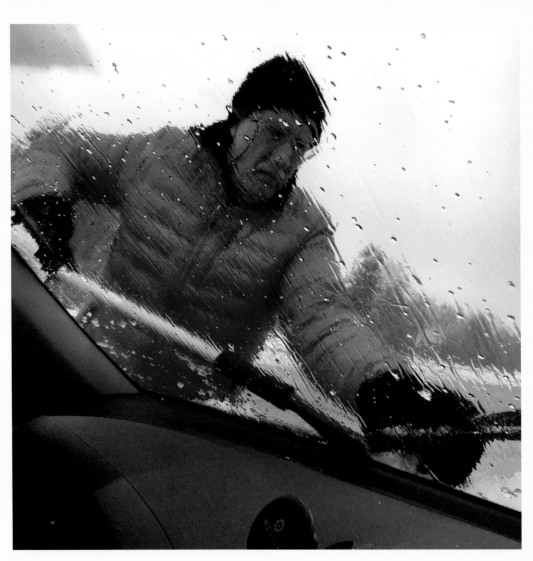

December 23, 2017

February 4, 2018

Picture Perfect
Porter, Maine

The stirrings of a snowy day at a friend's cabin in the Maine woods. Ice fishermen are already out on the pond in the distance, but in the time it took to post this shot, they have already disappeared into the gathering storm. Snow outside, a fire in the fireplace under that chimney and the prospect of a day with family, all without much talk of The News. Ahhhhhh.

Icy Merry-go-round

Rangeley, Maine

The fish are so big in the Rangeley region we have to cut 50-foot holes to get 'em out! Actually, this is Steve Philbrick and his son Tyler cutting an ice merry-go-round as part of the annual Cystic Fibrosis snowmobile benefit ride at Bald Mountain Camps in Oquossoc. Once the hole is cut, the outboard motor provides the power (typical Maine ingenuity) to spin the interior ice circle.

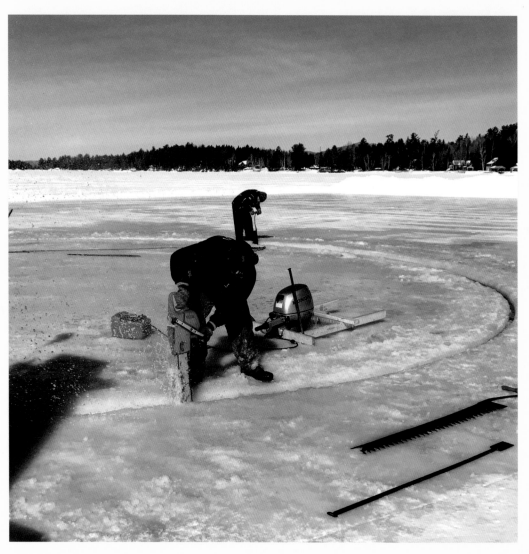

February 17, 2018

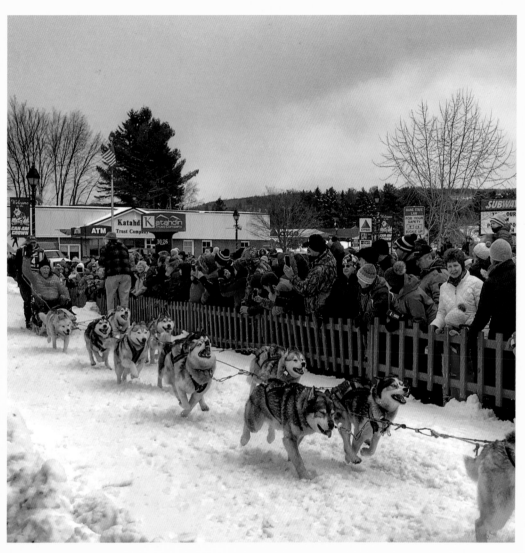

March 3, 2018

Mush!

Fort Kent, Maine

Mush! (which they really do say). This is the 26th annual Can-Am Crown International Sled Dog Race in Fort Kent, Maine which attracted mushers from across Canada and the U.S. (and even a team from France). I got a ride at the start and jumped out unceremoniously a couple of hundred yards down the track. Sorry about the cheesy wave, but I wanted to demonstrate that I was cool and not holding on for dear life (which I was, with the other hand). This is a wonderful community event in the St. John Valley, one of Maine's really special regions. It is populated largely by Franco-Americans who trace their lineage to the Acadians of Nova Scotia—first cousins of the Cajuns of Louisiana (say "Acadian" ten times fast and you get "Cajun"). I try to convince them that my real name is LeRoi, but they aren't buying it.

Answering Lots of Questions
Rangeley, Maine

Watching a Rangeley sunrise—and enjoying a day off, sort of! Mary and I are in Rangeley for the weekend with no agenda, save Passover today and Easter services Sunday morning. Reading, hiking and visiting downtown sounds like a vacation to me. The "sort of" part is that I did bring along a notebook full of draft letters to edit and approve. We get between 3,000 and 5,000 letters and emails a week (just from Maine!), and I believe that if someone takes the time to write, we should take the time to provide a real answer. So we have a group of bright young people on the Washington staff who read and draft answers (in conjunction with the policy staff) for me to go over and approve. I try to keep up with these during weeknights, but you can often catch me poring over the notebook on the plane home. Or in this case, while looking out at the frozen lake. (Just noticed—those are the notebooks under the lamp!) You may not always agree with where I land, but at least you'll know how I got there.

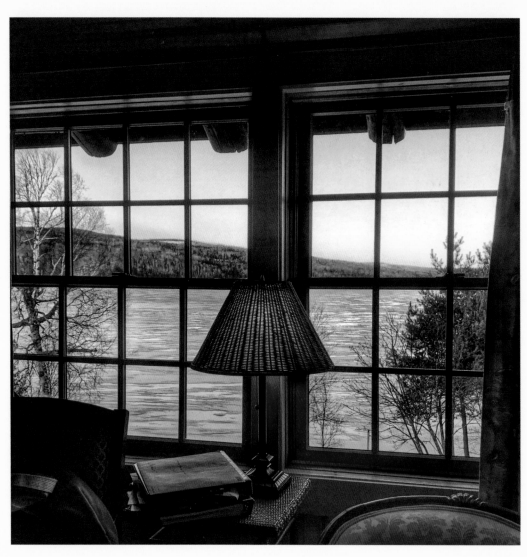

March 31, 2018

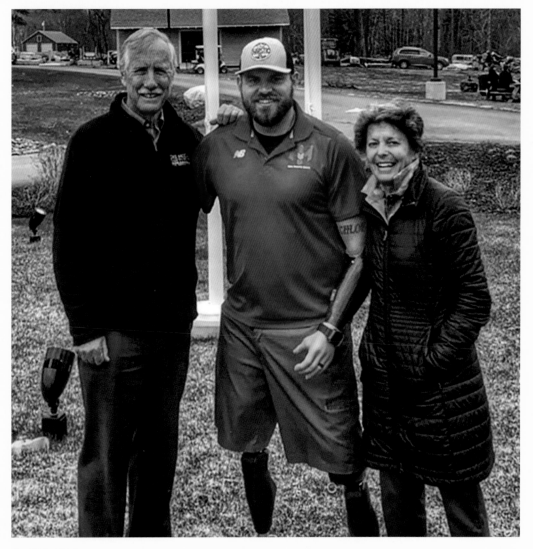

April 29, 2018

Inspiration Defined
Rome, Maine

Travis Mills is about the most downright inspiring person I've ever met. In the spring of 2012, he lost all four limbs in an IED explosion in Afghanistan—and less than five years later opened a fantastic retreat house in central Maine (at the old Maine Chance Spa) to provide rest and respite to "recalibrating" veterans and their families from across the country. Mary and I visited with him today (along with about 750 other fans from all parts of Maine) at an open house at the center. You can learn his incredible story at www. travismills.org, but what I want to convey here is a flavor of his indomitable spirit— after all he has been through, he's still optimistic, positive and really funny. As we waited in line to say hello, everyone around us had the same reaction—our problems suddenly didn't seem so all-fired important. It's one thing to face adversity with courage and grit, but to do so with that infectious smile as well is the definition of inspiration.

"May I Help You?"

Topsham, Maine

"May I help you?" This was my greeting at the Lee Nissan parts department in Topsham on Friday afternoon. Roxy here belongs to Phil, who was the guy who actually helped me out. This face is pretty appealing, but it was the paws on the counter that really got me. I guess it's a good thing I didn't need a CATalytic converter!

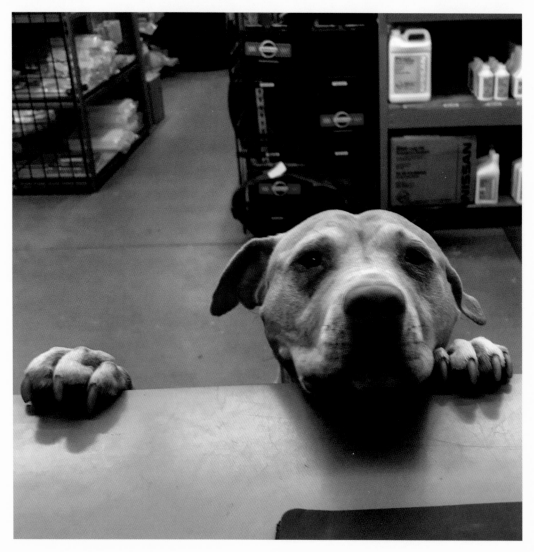

May 5, 2018

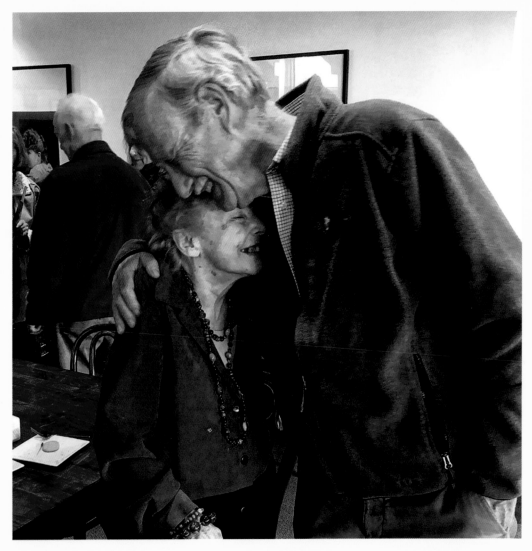

May 14, 2018

Old Friends

Presque Isle, Maine

If you can photograph genuine affection between two people, this is it. Almost 20 years ago, the Maine Learning Technology Initiative (better known as the Laptop Project) hung by a thread in the Legislature—and you're looking at that thread. After debate on the governor's crazy idea (mostly opposed), the Education Committee was ready to vote—unanimous Ought-Not-To-Pass, which would have effectively killed the whole idea. But Mabel Desmond of Mapleton, a tiny town in far northern Maine (who was a former seventh-grade teacher herself) cast the single dissenting vote, and we were still alive. After that lonely and courageous vote, the program was ultimately adopted and every seventh- and eighth-grader in Maine—no matter their family circumstances or where they live—has had their own laptop to use during their school years from that day to this. Mabel represents the best of Maine— honest, smart, tough and caring. Down on the coast where I live, they'd call her Finest Kind.

A Night of Community Pride

Boothbay, Maine

Day's end in Boothbay Harbor. Helped hand out awards at the annual Chamber dinner tonight and this is the view that greeted us on the way home. I love these dinners because they combine community pride, recognition of accomplishment on the local level (where it really counts) and always a warm, mutually supportive atmosphere. Sometimes people say that the steering wheel of the country is in Washington, but I've always thought that if that's true, it's not attached to the engine; the engine is those good people in Boothbay—and in thousands of towns like it (and yes, in cities, too) from Maine to Hawaii.

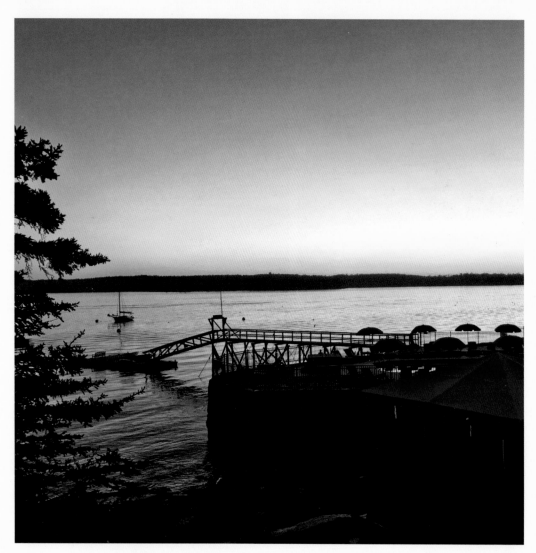

May 31, 2018

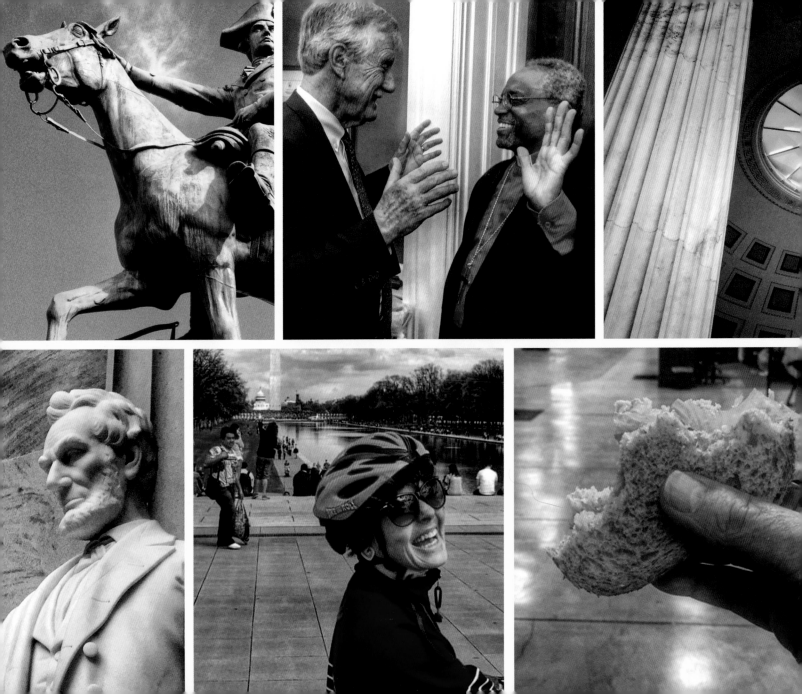

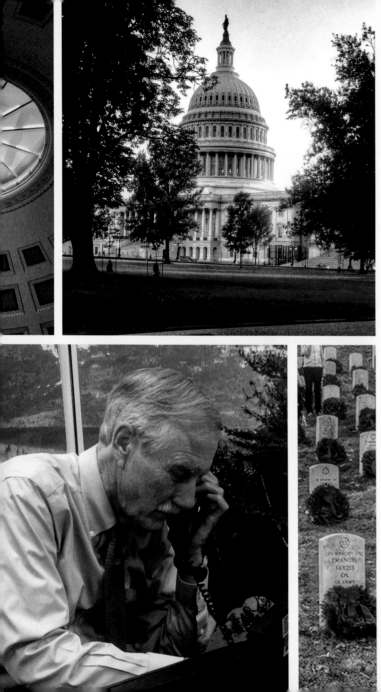

On the Hill

One of my intentions when starting with Instagram was to share a slice of my everyday life as a senator and provide the occasional inside look at the workings of Washington. And one of the things I've learned over the past five years is that senators are pretty much ordinary Americans from a variety of backgrounds, all trying to do what they think is best for the country—as much as we often might think otherwise. Plus, we still have to grab a quick lunch between meetings, shop for groceries and share the occasional late-night pizza.

Washington is a stunningly beautiful city steeped in history, with wide avenues, marble monuments, grand buildings and inspiring vistas. One of the themes in the section that follows, however, is that those of us privileged to work here are not doing a very good job of living up to the magnificence of our surroundings.

But I'm determined to keep trying; after all, that's why the Framers set us on a quest to establish "a more perfect Union." In other words, we're not there yet—and never will be, but that's no reason to give up the effort.

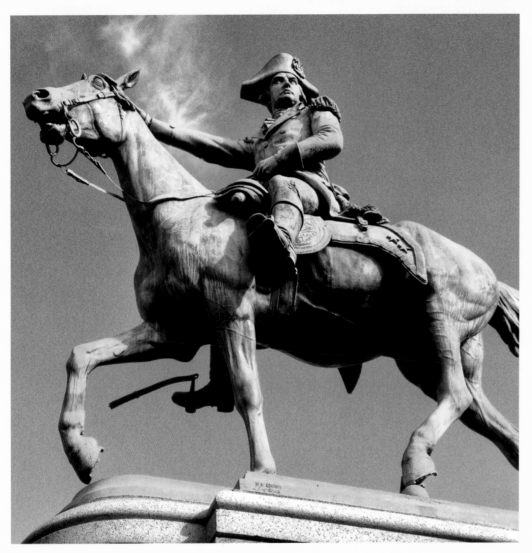

General Nathanael Greene
Washington, D.C.

Washington, D.C. is a city of impressive monuments. Here is General Nathanael Greene of Rhode Island, a hero of the American Revolutionary War, charging across a grassy square just east of the Capitol. I passed him walking to work this morning and was struck by the power of his image against the deep blue sky.

September 23, 2014

A Glamorous Life

Washington, D.C.

Ah, the glamorous life of a U.S. senator! I grabbed a sandwich in the little carry-out in the basement of the Capitol and ducked into the Kennedy Caucus Room for a quiet lunch on the way back to the office. This is the large meeting room in the Russell Senate Office Building where the Watergate and Iran-Contra hearings were held. These walls have witnessed a lot of important moments in U.S. history, but I'm afraid my brief lunch wasn't one of them. The blue stripe on the floor is the late morning sun from the doorway to the right.

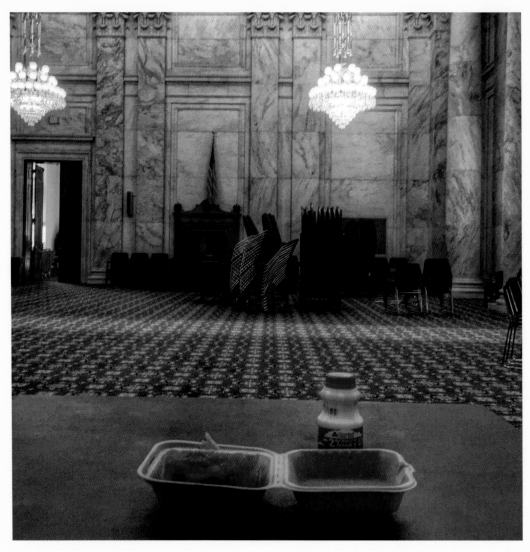

January 9, 2015

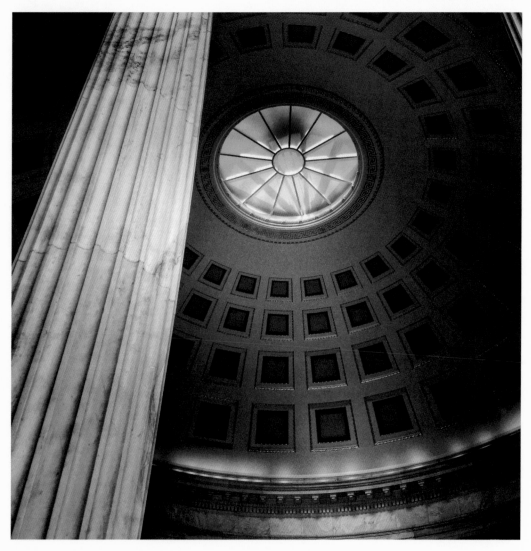

The Old S.O.B.

Russell Senate Office Building, Washington, D.C.

The mini-rotunda in the Russell Senate Office Building. (When I worked in this building in the '70s, it was simply known as the Old Senate Office Building, or Old S.O.B., for short.) When you watch senators being interviewed on CNN, Fox, MSNBC or the other cable channels, this is often the setting. Each channel has a small setup at a specific space around the edge with a camera and sound equipment. Next time, watch for the columns and you'll know where we are.

January 11, 2015

Once and Future Cooperation

Washington, D.C.

A historic joint caucus lunch. Just think, Republicans and Democrats (and Independents like me and Bernie Sanders) sitting down to break bread together! Here, Republican Senator Orrin Hatch of Utah is talking about how the Senate used to work—and how he once worked cooperatively with Senator Ted Kennedy, the Massachusetts Democrat. No promises, but moments like this might just nudge us all toward a more productive relationship. Here's hoping.

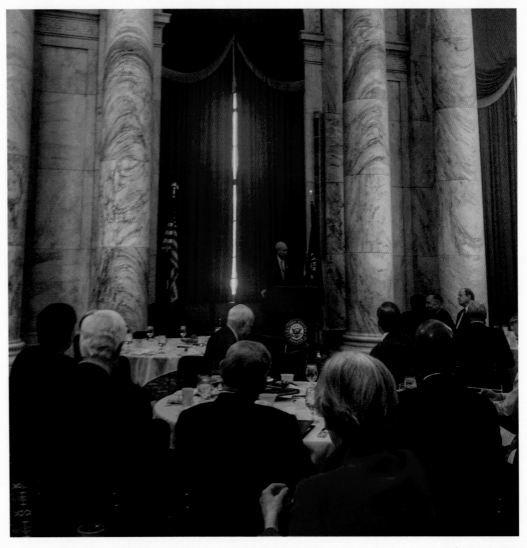

February 4, 2015

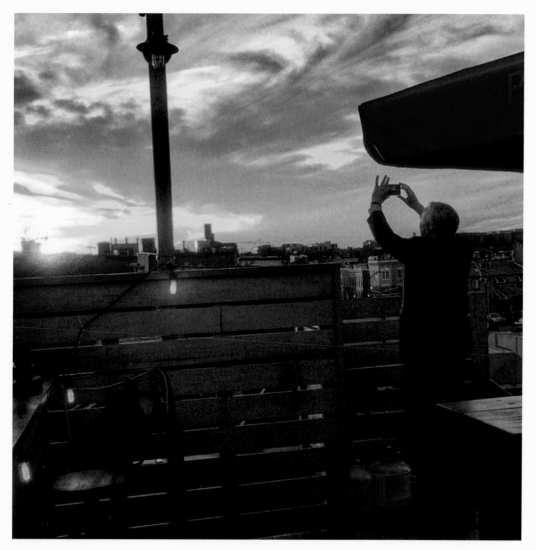

Capturing a Sunset
Washington, D.C.

So, it turns out a member of my staff got a shot of me getting a shot of the sunset. Mary and I are taking a gang from the office out for pizza. I—and the people of Maine—have an amazing group of young people working with us. Anything I accomplish is largely due to their quiet, hard work.

March 12, 2015

Super Bowl Champs

The White House,
Washington, D.C.

I'll admit it—there are some cool things about being a senator, and one of them is being invited to the White House celebration for our Super Bowl champion New England Patriots. The president started out his remarks by saying that he had 12 jokes, but with the Patriots here, he was afraid 11 of them would fall flat(!). I'm not sure I'd have had the nerve to try that one with Bill Belichick and all those huge guys standing right behind me—but it got a big laugh, nonetheless. It was fun to relive the last minutes of one of the best Super Bowls ever played. Great game, great team.

Note: The New England Patriots won Super Bowl XLIX, beating the Seattle Seahawks 28-24.

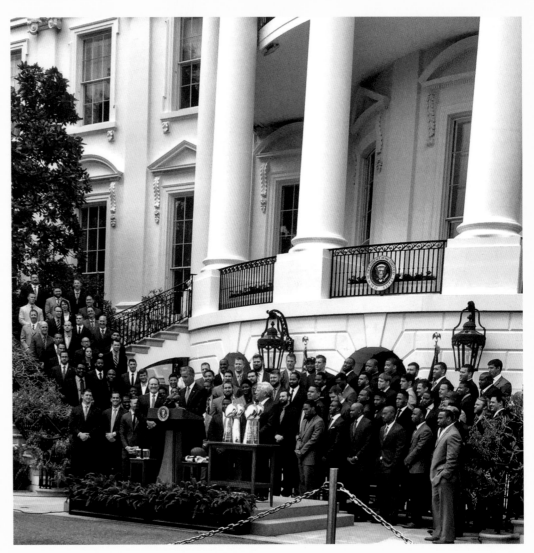

April 23, 2015

Ham and Cheese on Wheat

Washington, D.C.

The glamorous life of a U.S. senator, Part 3. Quickly eating a sandwich on the way to a vote on a trade bill (I voted no).

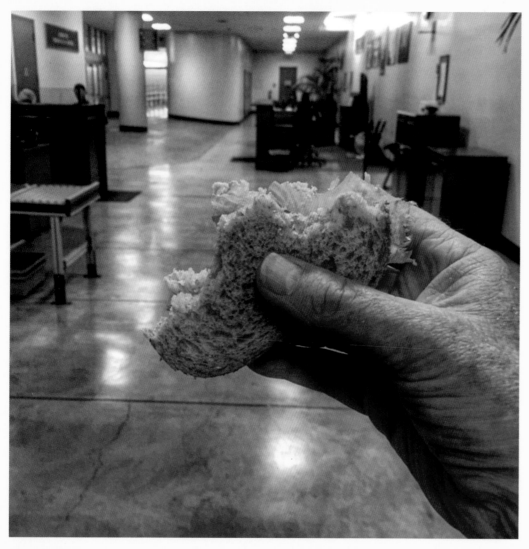

May 14, 2015

Union Station
Washington, D.C.

Walking home tonight, caught this sunset behind the venerable Union Station. It was a clear, crisp day—but Washington's trademark heat and humidity are on the way.

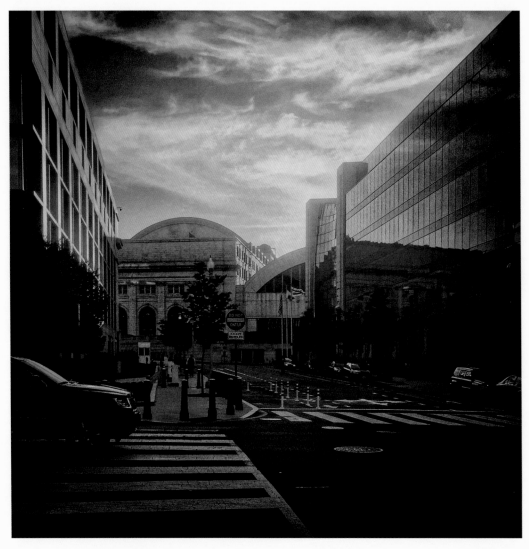

May 20, 2015

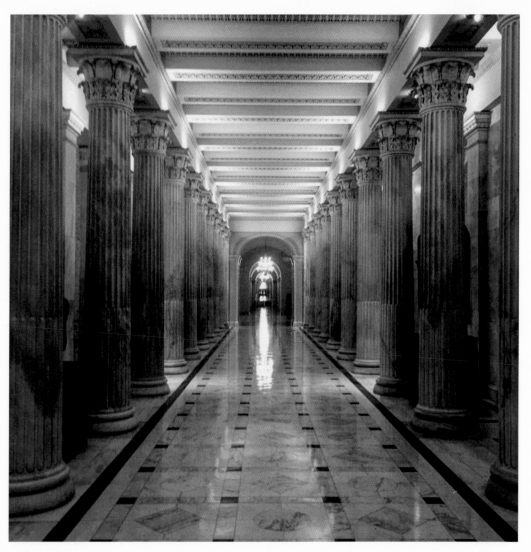

Sending a Message
Washington, D.C.

This is the first floor of the U.S. Capitol, under the House chamber, looking north toward the Senate at about 7:30 in the evening. I think the designers wanted to impress the members of Congress (and their constituents) with the gravity of their responsibilities through vistas such as this. They sent us the message—unfortunately, we don't always listen.

September 15, 2015

Communicating

Washington, D.C.

My friend Scott Ogden passed along this shot of me holding forth with Chris Cuomo on CNN's "New Day" this morning. The subject was Pope Francis' visit to Washington and the possible impacts of his presentation to Congress. I just read an advance copy of the speech—very powerful. This guy (the Pope) looks like the real deal.

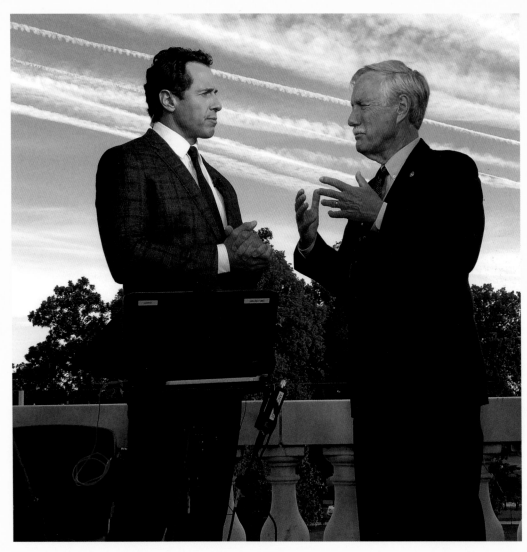

September 24, 2015

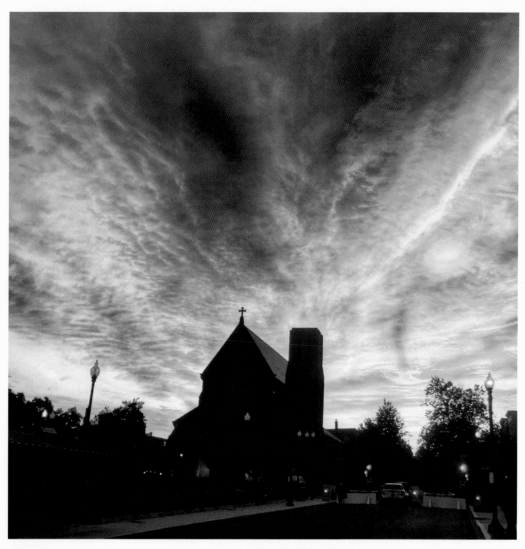

Waiting for the Pope
Washington, D.C.

I came in early this morning and was greeted by this spectacular sunrise over St. Joseph's on Capitol Hill Roman Catholic Church, just across the street from my office. Somehow this just seemed appropriate, given that Pope Francis will be here in a few hours.

September 24, 2015

Looking Down the Mall
Washington, D.C.

I was at a meeting in the Capitol this afternoon and couldn't resist this shot looking down the National Mall to the west at the Washington Monument. Just taking a few quiet moments to look out this window served as a welcome break from a day spent almost entirely discussing Syria, Iraq, Iran and Russia. No easy answers—one of my colleagues said as we left a briefing this afternoon, "the more you learn, the more complicated it gets."

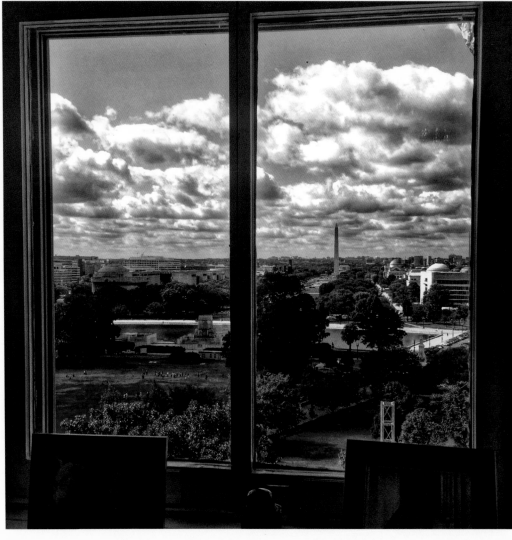

October 7, 2015

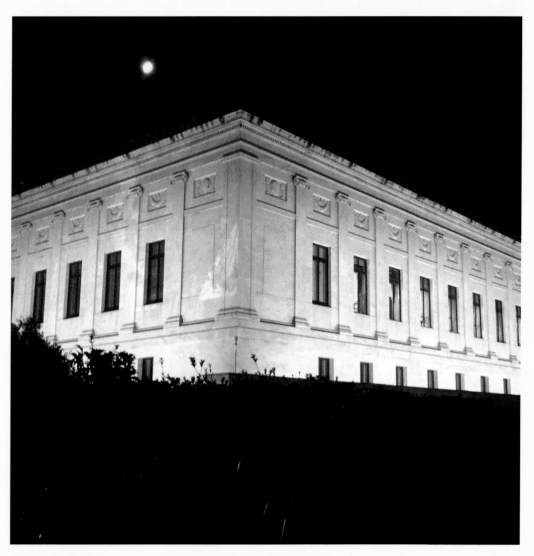

North Side of The Supreme Court
Washington, D.C.

Here's one of my "views you don't usually see in Washington" shots, taken while walking back from dinner last night. It's the north side of the Supreme Court Builkding with the distant moon in the background. The last few days have felt like September in Maine—warming during the day, ultra-clear and cool at night. Now, if we can just get a few problems solved around here, we'll be worthy of these grand buildings.

October 29, 2015

Library of Congress
Washington, D.C.

The corner of the Library of Congress lit by the setting sun. While it's impressive outside, the library's real glory comes from its ornate spaces inside—not always on the tourist lists, but definitely worth a stop when in Washington.

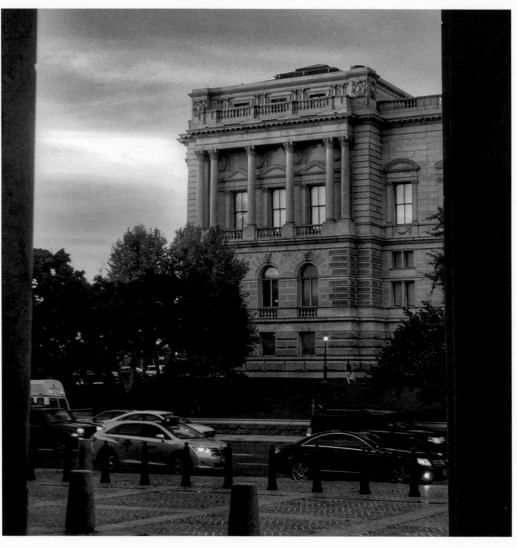

October 29, 2015

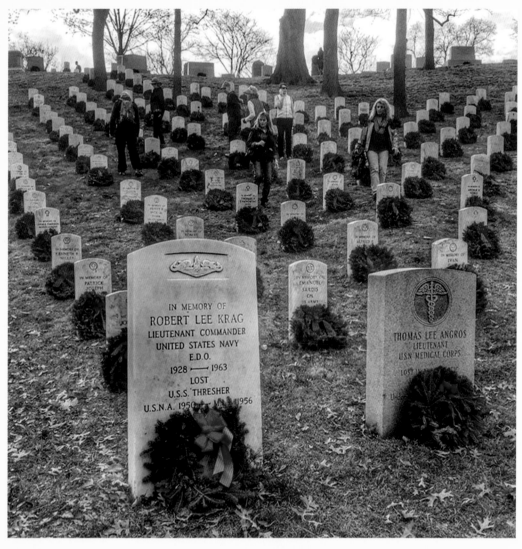

December 12, 2015

Wreaths Across America

*Arlington National Cemetery,
Washington, D.C.*

A tiny slice of the tens of thousands of graves decorated by Maine-made wreaths at Arlington National Cemetery this morning. The entire hillside is populated by volunteers from all over the country (I've met about 20 people from Maine) placing the wreaths. A very moving experience. A group of us from the office are helping lay the wreaths on every single grave (there are 244,000 here) as part of the amazing Wreaths Across America project led by Morrill and Karen Worcester of Washington County. My first stop was at the grave of my old boss, mentor, and friend, Sen. Bill Hathaway. I loved the guy and a young man couldn't have had a better role model.

Walking with History

*The White House,
Washington, D.C.*

OK, couldn't resist this one. I was invited to the state dinner at the White House last night in honor of Justin Trudeau, the new Prime Minister of Canada. (I seem to have made the guest list by virtue of living in close proximity to the Canadian border—Sen. Susan Collins and I represented Maine, while other senators represented New Hampshire, Vermont and Minnesota.) This wonderful portrait of Teddy Roosevelt hangs in the west dining room and one of my dinner partners told me to strike this pose.

What a thrill—walking with history. And Trudeau is very impressive; my only problem with him is that he's the same age as my two oldest sons!

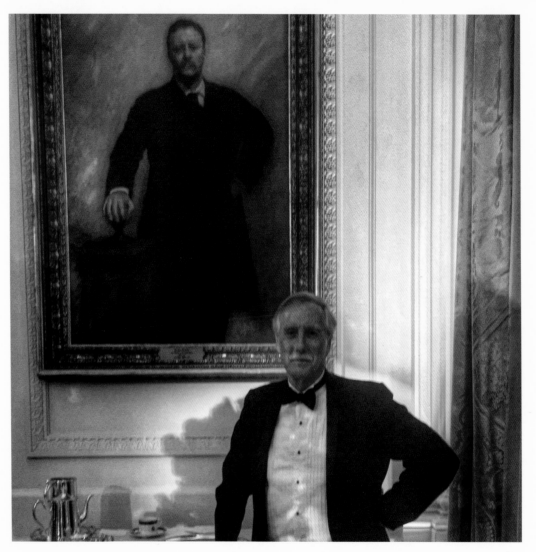

March 11, 2016

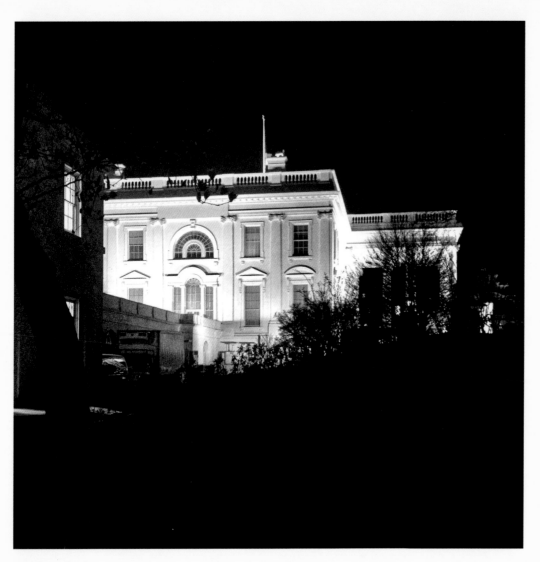

The White House
Washington, D.C.

Leaving the White House on a warm spring night. This is the east wing, looking west. Walking by the portraits of Lincoln, Kennedy, both Roosevelts, Nancy Reagan and all the others who made their home here is sort of overwhelming. For a guy who thinks a lot about history, this is sacred ground.

March 11, 2016

Happy Birthday, Maine!
Washington, D.C.

Happy 196th Birthday, Maine! All the state flags and seals are arrayed along the tunnel from the Dirksen Senate Office Building to the Capitol in the order of their admission to the Union. So here's Maine right after Missouri, its partner in joining the country in 1820. (Why is it called the Missouri Compromise? Why not the Maine Compromise? Maybe Missouri had a better press agent.) Fun to see our familiar flag on my walks back and forth—or from the trolley when I'm late!

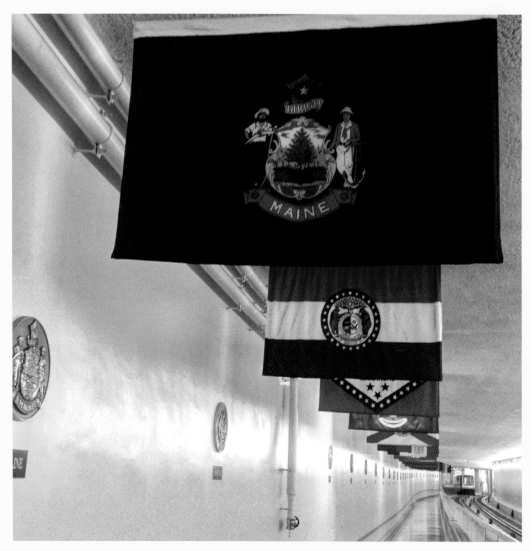

March 15, 2016

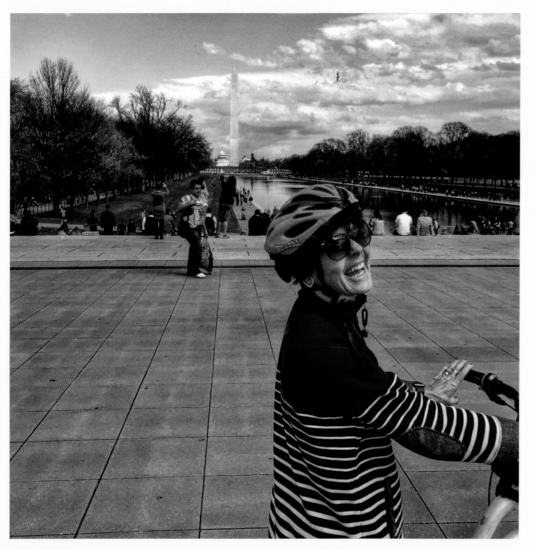

Saturday on the Mall
Washington, D.C.

Mary and I spent a rare Saturday in Washington, so we rented bikes at Union Station and rode the length of the National Mall and back. The hardest part of the ride was navigating the people—the sidewalks and streets were jammed—but it was fun to watch everyone taking in the extraordinary sights. If you look closely in the background, you can just make out hundreds of kites flying up near the Washington Monument.

April 2, 2016

What Would Our Parents Think?

Washington, D.C.

OK, so this isn't so "Insta" but it's a great shot of my Chief of Staff Kay Rand who joined me at the recent White House dinner for new Canadian Prime Minister Justin Trudeau (who can be seen in the background behind the president). On the way in, Kay and I kept talking about what our parents would think if they could see us in this place. If you're wondering what President Obama is saying to Kay, it was something along the lines of: "Sorry you have to work for such a knucklehead—oh, hi there, Angus."

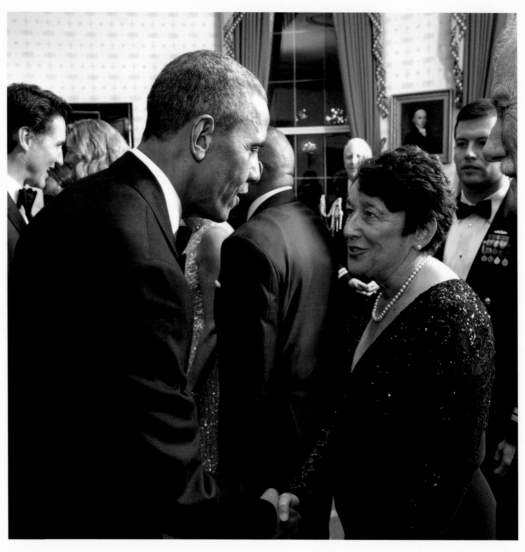

May 17, 2016

Happy Faces

United States Capitol,
Washington, D.C.

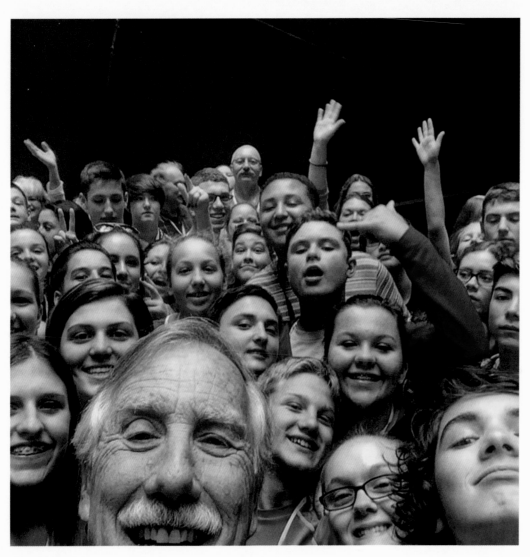

Biddeford Middle School comes to the Capitol for a selfie! Great group of young people visiting this week, seeing the sights and picking up some background on what we're up to around here. They did well on my quiz (Who's Maine's other senator? What is the president's term? What color is the White House?) and, as you can see, are having a pretty good time. This is a fun part of the job!

May 23, 2016

Lion of the Civil Rights Movement

Washington, D.C.

It's not often you get to meet one of your lifelong heroes, but it happened to me today. This is the legendary U.S. Representative John Lewis, one of the lions of the civil rights movement. John was the youngest speaker at the March on Washington in 1963 with Rev. Martin Luther King Jr. This was a special moment for me because I was there, too—just an idealistic 19-year-old sitting in a tree up near the Lincoln Memorial. On the off chance you recognize that building behind us, the occasion of our meeting was the annual White House congressional picnic. What a privilege; what an experience.

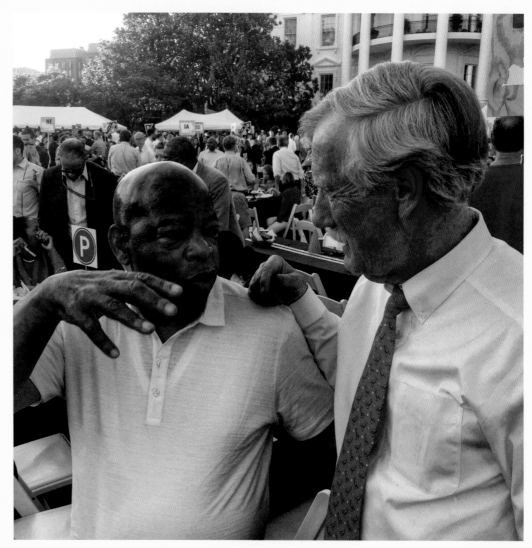

June 14, 2016

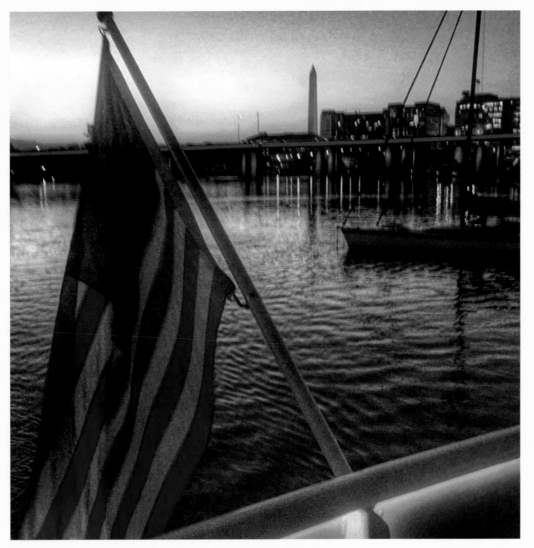

On the Potomac
Washington, D.C.

Sunset on the Potomac. The blue line is the lighted edge of the 14th Street Bridge.

July 8, 2016

Angus King: Tour Guide

United States Capitol, Washington, D.C.

For some reason, I just love this picture. Recently, members of the Emblem Club of Farmington visited Washington and came over to see me just off the Senate floor. It happened to be the day the Capitol rotunda was opened up after almost two years of repairs, so we went on an impromptu tour. Guiding, in this case, also entailed being the official photographer! Their shirts were a great hit and drew lots of smiles and pictures as we made our way through the Capitol's corridors. Thanks to Marge Kilkelly for this great shot—and the ladies of the Emblem Club for brightening our day!

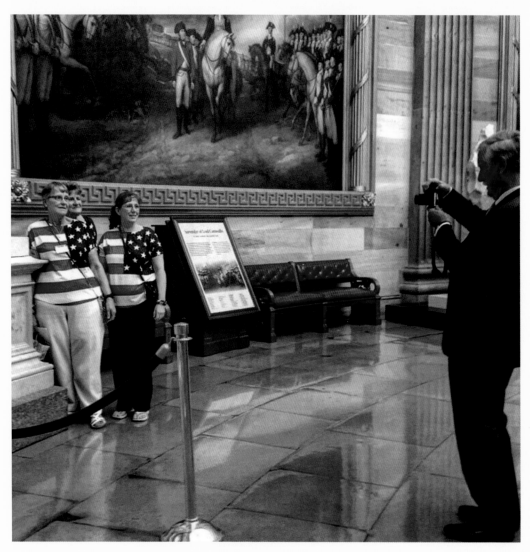

September 28, 2016

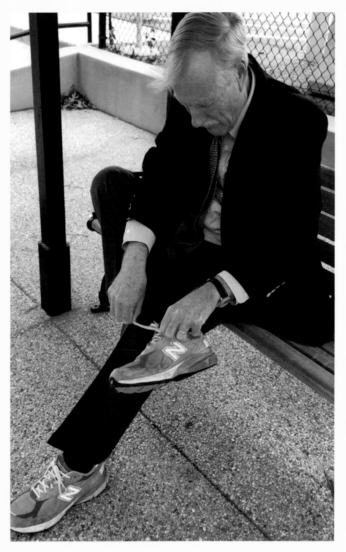

December 8, 2016

Lacing Them Up for the Troops

Capitol Hill

Getting ready for work this morning involved a special moment—strapping on my New Balance shoes made in Maine. What made it special was that today Congress passed the National Defense Authorization Act, which contains a provision all of us in the Maine delegation have worked on for years—requiring the Pentagon to buy American-made athletic shoes for the troops. It meant a lot to me because of the number of times I've visited with New Balance workers in Maine and the pride I take in representing them. It also felt good because getting the provision into the bill and keeping it there despite some serious opposition wasn't easy. Getting things done down here is often tough, so a win like this—which will have tangible benefits for families in Maine—feels pretty darn good.

Two Kings in the Capitol

*United States Capitol Building,
Washington, D.C.*

This is me with the "real" Governor
King—William King, first governor of
Maine. He stands just outside the House
Chamber in the Capitol and I always get
ribbed by colleagues in the vicinity when
walking by. This shot was taken by Sen.
Ted Cruz, a Republican from Texas, whose
comment when he forwarded it to me
was: "All the statue needs is the mous-
tache." I don't mind being teased, as long
as it's bipartisan.

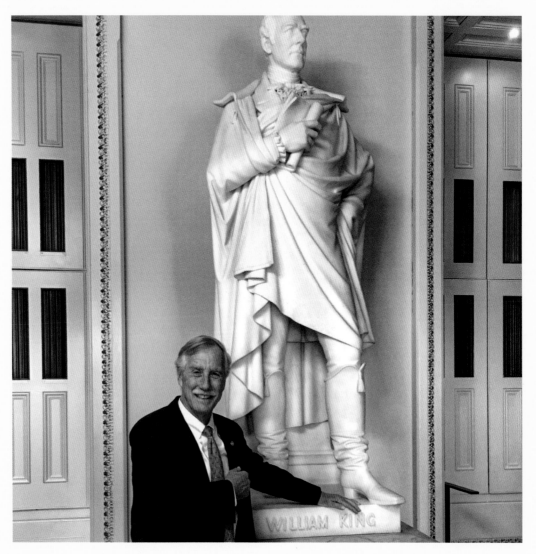

January 6, 2017

A Presidential View

United States Capitol Building, Washington, D.C.

If you were elected the new president, this would be your view as you emerged from the Capitol and stepped onto the Inaugural platform. Sen. Ted Cruz of Texas is in front of me and to his immediate right is Sen. Jeff Flake of Arizona. The inauguration ceremony starts in a few minutes.

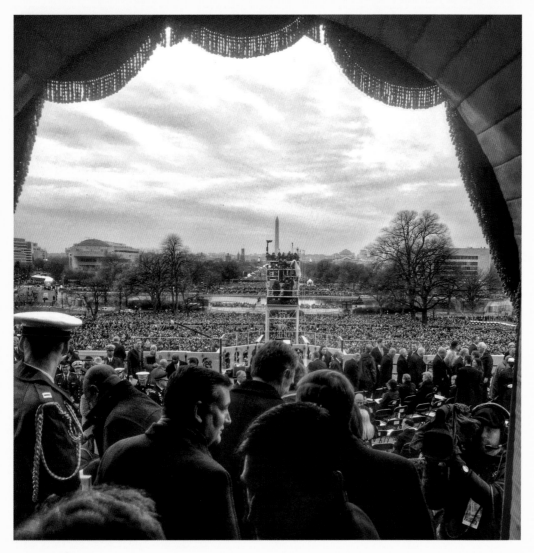

January 20, 2017

Late-Night Walk
Washington, D.C.

One good thing about a late-night session is that when you take a walk, you see something like this. I just wish the debates taking place on the inside lived up to the magnificence of the outside.

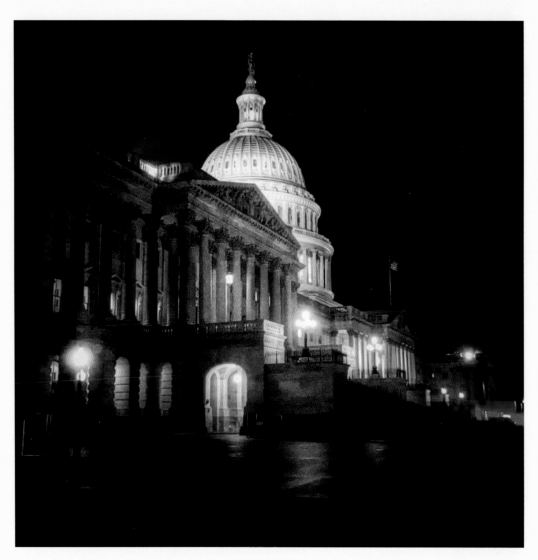

February 7, 2017

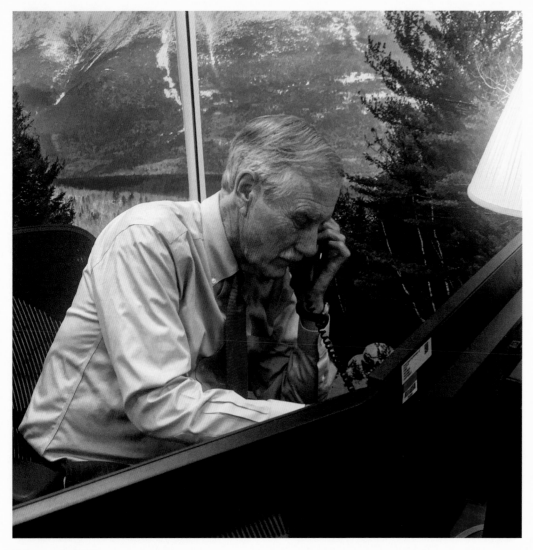

Hello, Senator King's Office

Washington, D.C.

What a week! We usually get about 2,000 calls and emails a week; but as of today, we're already over 20,000, fueled by pending votes on cabinet nominations. On Wednesday, I took a turn at the phones (Mary did the same at our Augusta office). It was very powerful to hear directly from so many people—and fun to tell them they didn't have to leave a message, because they had the senator himself on the line. The calls came from all over Maine and almost entirely urged "no" votes on Betsy DeVos and Jeff Sessions— and that's what I did.

Note: Betsy DeVos was appointed Secretary of Education and Jeff Sessions was appointed Attorney General.

February 10, 2017

Just Another Day

United States Capitol Building, Washington, D.C.

Just another day at the office; I mean really. Still pinch myself that I get to work in this place—and can't help going for shots like this. The guides think I'm one of the tourists.

February 10, 2017

February 15, 2017

In Case of Emergency

United States Capitol Building, Washington, D.C.

OK, this is sort of a dorky picture, but it's a funny story. I was leaving the Senate floor after a vote and heading back to the office—when the elevator froze. Froze as in no motion, doors locked shut, and the absolutely chock-full elevator growing warm. The guy on the phone in front of me is Sen. Jon Tester of Montana trying to summon help, but his office thought he was kidding. Meanwhile, I was periodically pushing the alarm bell (did you ever notice that button?) hoping someone on the outside would figure out what was going on. Finally, after about 15 minutes (which seemed like at least an hour), a mechanic came and pried the doors open. Oh, and of course, one of the passengers was a reporter. Don't know what caused the problem, but my bet is it was the Russians.

Sunset on the Dome
Capitol Hill, Washington, D.C.

Here's me being a tourist again. Couldn't resist this shot of the late afternoon sun on the Capitol and Jack Faherty couldn't resist the shot of me getting the shot. More meta-fun!

March 10, 2017

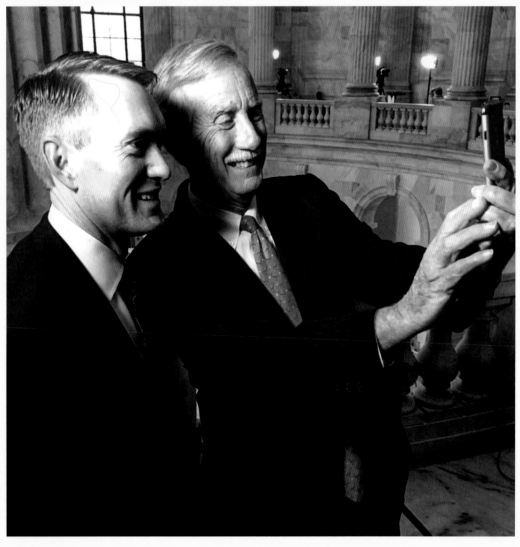

You Can Disagree Without Being Disagreeable

Russell Senate Office Building, Washington, D.C.

Nonpartisan selfie! This is my friend James Lankford, a Republican senator from Oklahoma. We serve together on the Intelligence Committee and are actively working to keep the Russian hacking investigation on track and nonpartisan. While we often disagree on policy issues, I have found James to be thoughtful and a person of real integrity. Relationships matter—and I've always tried to follow my dad's advice: "You can disagree without being disagreeable."

March 30, 2017

The Future's So Bright I Gotta Wear Shades

Hart Senate Office Building, Washington, D.C.

Last days for the spring interns! All congressional offices have interns, but mine are always the coolest, as you can plainly see. I try to make sure that they have a meaningful experience by including them in policy meetings, taking them to hearings and just hanging out from time to time (including at a classy breakfast in the Senate Dining Room). Our winter-spring crew includes (from left) Sam Morse of Peru (Maine, that is), Joe Lemoine of Saco, Kate Durost from Bucksport and Rowland Robinson of Portland. Missing from the shot is Jacqueline Forney, who grew up in Indiana, but had the good sense to come to Maine for college (Bates). They have been fun to get to know and have made a real contribution to our work. I'll miss 'em.

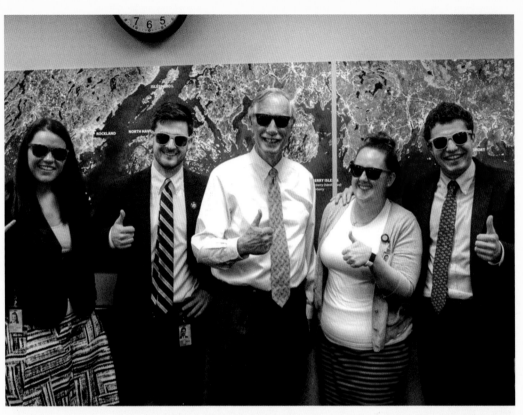

April 27, 2017

Meet the Press
Washington, D.C.

Sunday morning with the Veep. Vice President Pence and I are in the "green room" (wonder why it's always called that?) waiting to go on *Meet the Press* with Sen. Susan Collins. Just behind Susan is MSNBC journalist Chris Matthews. We were invited to talk about why the Senate doesn't work and what can be done to help. Nice for Maine that we're both viewed as more problem-solvers than partisans.

April 30, 2017

In the Humbling Presence of Greatness

United States Capitol Building, Washington, D.C.

Just inside the west entrance to the Capitol Rotunda stands this solemn likeness of the greatest citizen America has ever produced. With but one year of formal education, Lincoln had a profound understanding and deep love for his people. His writings—funny, persuasive and often profound—still ring as true today as they did 150 years ago. Stop for a moment and read the second inaugural address, his agonized and deeply religious attempt to make sense of the Civil War. For those few moments, you'll be in the presence of genius.

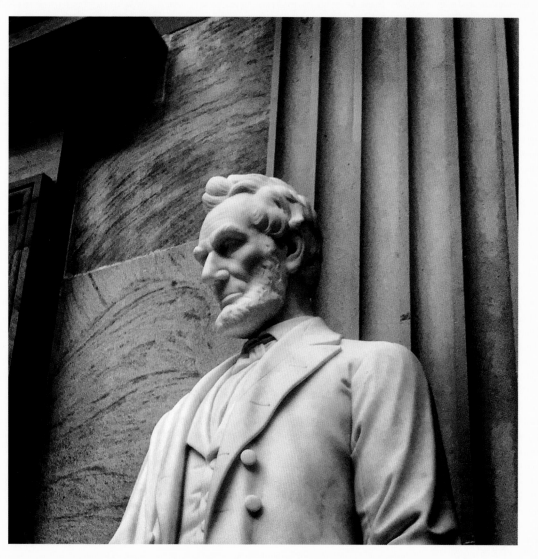

May 25, 2017

June 26, 2017

Talking Health Care with 10,000 Mainers

United States Capitol Building, Washington, D.C.

So this looks like a garden-variety telephone call in my office—except this time there were 10,000 Maine people on the other end of the line! For a little over an hour, I answered questions on a tele-town hall hosted by AARP Maine on health care, specifically on the Senate Republican health care proposal announced in June 2017. Really great to hear from so many Mainers. My conclusion after a lot of study is that this bill came out of a terrible process (no hearings, no outside input, no bipartisan discussion, no time), and, not surprisingly, it's a terrible bill (massive cuts to Medicaid, higher premiums for seniors, thinner coverage—all in the name of a huge tax cut for those who need it the least). I don't come at this as a partisan issue; the question is, how will it affect the people of Maine, and from all I've learned (including from my callers tonight), it's bad for many and a downright disaster for others. We can do better.

What it All Means
Washington, D.C.

Flying into the city from the west. As I was taking this shot, one of the guys in my row seemed surprised I had the camera out. "Don't you see that all the time?" "Yeah," I answered, "but I never get over what it all means." And in spite of these tough times, I don't think I ever will.

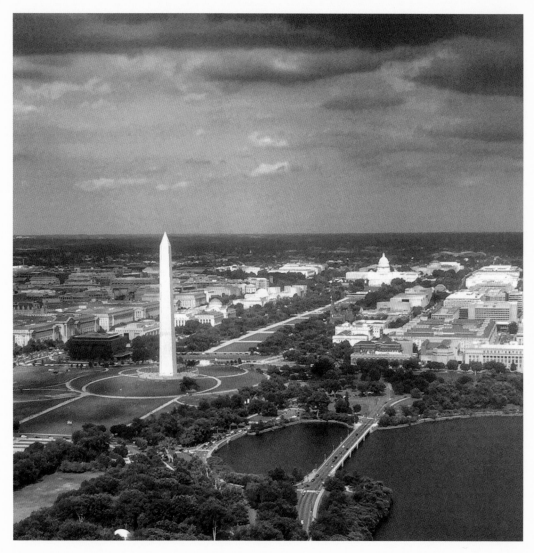

July 24, 2017

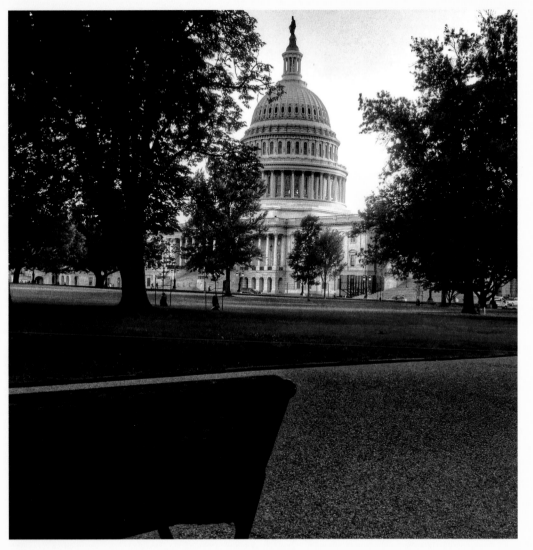

Fleeting Moments of Quiet Time

United States Capitol Building, Washington, D.C.

This is really a shot of the bench—with a nice view thrown in. Walking back to the office, I stopped to just sit for a minute and suddenly realized how unusual it is to have a little quiet, unscheduled time. After a few minutes, however, I started to feel guilty (at the end of the day, there are always emails to attend to, background memos to read or calls to return) and I headed back. But the moment was nice while it lasted.

July 26, 2017

John McCain, Action Hero

United States Capitol Building, Washington, D.C.

I love John McCain. This picture was taken a few hours before the dramatic Senate vote to reject the repeal of the Affordable Care Act. A couple of weeks ago, a friend in Maine gave me a mint condition John McCain Action Figure, which I passed on to John just off the Senate floor late Thursday afternoon. As the whole world knows by now, the Republican senator from Arizona cast the deciding vote against repeal, bucking his party, as did Sen. Susan Collins and Sen. Lisa Murkowski of Alaska. In my career in public life, I have never seen such courage as we saw from these three last night. It's easy to stand up to your opponents, but it's hard to stand up to your friends. Now it's time for all of us to work together to fix the ACA and the deeper issues of high medical costs to make healthcare affordable and accessible for all Americans.

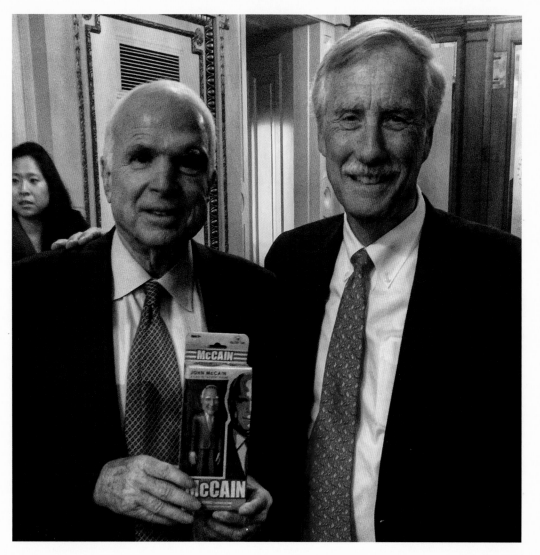

July 28, 2017

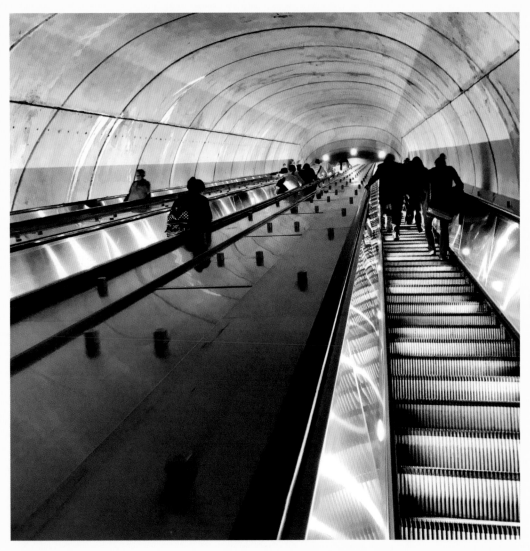

Do You Know How to Use the Metro, Senator?

Washington Metro, Washington, D.C.

Here's a sight you don't see in Maine very often. Maybe never. It's an impossibly high escalator exiting the Woodley Park station on the Washington Metro. I was on the way to a birthday dinner with daughter Molly and the Red Line from Union Station was a quick and easy option. What hurt, however, was the question from a young member of my staff on the way out of the office: "Do you know how to use the Metro, Senator?" Harrumph; How do they think I got around before all this Senator stuff? By the way, I came back on the Metro as well, even successfully negotiating the change of trains at Gallery Place. So there.

September 12, 2017

Late-Night Pizza
Washington, D.C.

Another picture in the Glamorous Life of a U.S. Senator series. All day and into the night we voted on amendments to the budget resolution, and here's the pizza that helped carry us through. At the end of the table are Virginia Sen. Tim Kaine (with New Jersey Sen. Cory Booker just behind him), Sen. Bob Casey of Pennsylvania, Sen. Maria Cantwell of Washington and some guy named Sanders from Vermont. In the foreground on the right is Sen. Joe Manchin sharing stories of the finer points of West Virginia politics.

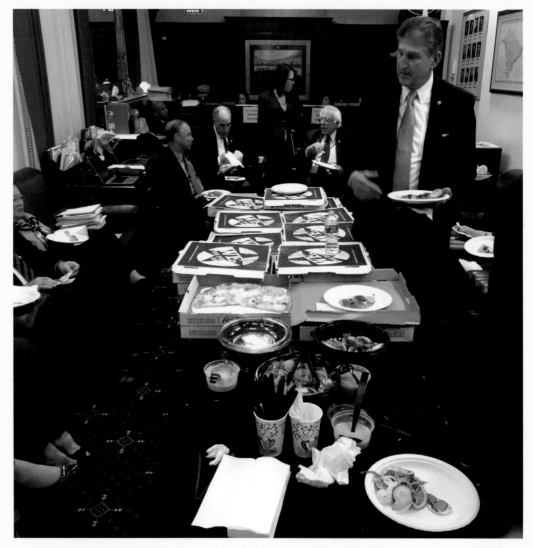

October 19, 2017

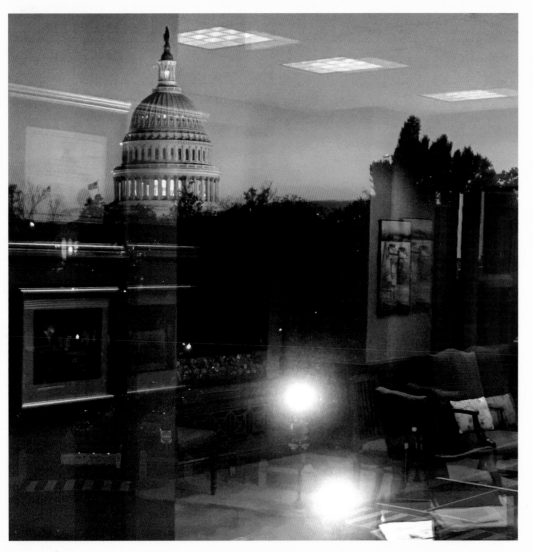

Your Reward?
This View.
Washington, D.C.

This is the view you get when you've been in the Senate for 20 years. Caught this shot from Sen. Susan Collins' office (which is reflected in the window) after a late afternoon meeting. She and I don't always agree (although we do more often than not), but when it comes to Maine, there's rarely any difference. And we keep in close touch—she says I text her more frequently than anyone except her niece!

November 13, 2017

Tax Tangle

Maine

An actual photo of the Senate tax reform bill caught in the wild!! Actually, I am helping my brother-in-law set up a new TV and this is what we found behind the desk—and when I saw the "simplified" tax bill, this is the first thing that crossed my mind. (You gotta maintain your sense of humor in my line of work.) And Happy Thanksgiving, everybody—we really do have a lot to be thankful for!

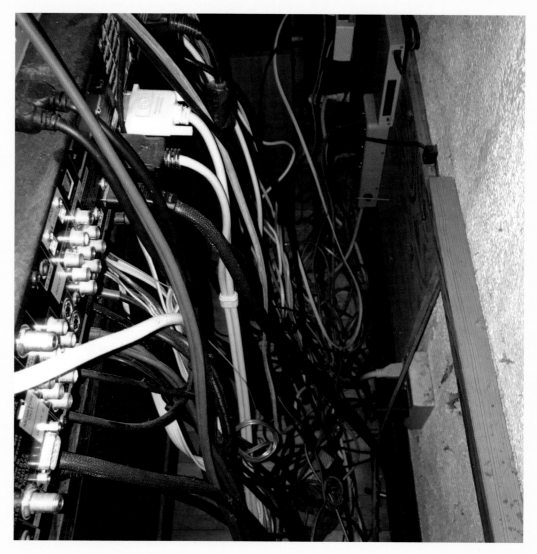

November 23, 2017

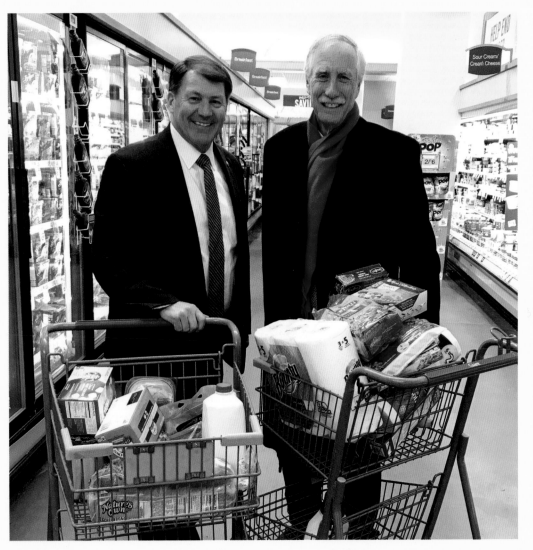

Getting the Groceries

H Street NE,
Washington, D.C.

This is a special entry of the Glamorous Life of a U.S. Senator series. Today in the neighborhood grocery store I ran into my friend Sen. Mike Rounds of South Dakota. Someone recognized me in the store a couple of months ago, and, looking somewhat shocked, said, "what are you doing here?" My response was pretty straightforward—senators have to eat, too (and do the laundry—notice the detergent peeking out at the bottom of my cart). Mike is one of my best friends in the Senate; he's a former governor and just plain levelheaded. We worked closely together on the Alexander-Murray health care bill, which I still hope we can get moving in the reasonably near future. And I guess Mike has to eat, too. By the way, I tipped him off that organic milk has a longer shelf life than regular. You've got to know these things.

Rock 'n' Roll Philosopher

United States Capitol Building, Washington, D.C.

Spending Saturday evening in the Capitol, unfortunately, because of the shutdown. We had nonstop meetings all day and saw some glimmers of progress, but so many forces (the other House, the president, the parties, just to name a few) are at play, that getting to a resolution is a serious challenge. Since last night, I and others have been engaged in shuttle diplomacy—back and forth between members and the leaders on both sides. I think we can get there, and make progress on some important issues, but it will take give on both sides, good faith and maybe the rarest commodity these days, a little trust. I made a speech on the floor this afternoon pushing for a solution and ended by urging my colleagues to heed the words of one of my favorite philosophers, Mick Jagger: "You can't always get what you want, but if you try sometimes, you just might find, you get what you need."

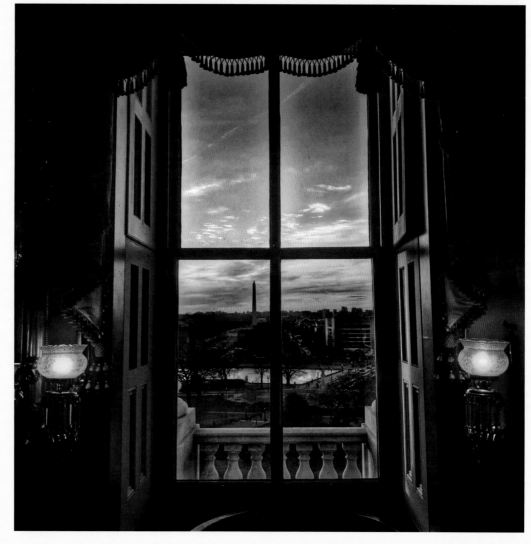

January 20, 2018

In the Room Where It Happens

United States Capitol Building, Washington, D.C.

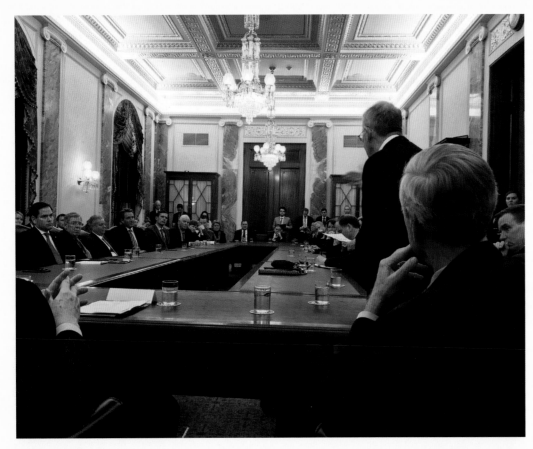

January 24, 2018

As they say in *Hamilton*, this is literally "in the room where it happens." We have two weeks to come up with a bipartisan solution to the DACA, or Deferred Action for Childhood Arrivals issue, and this is one of the six (six!) meetings I have attended on the subject in the last two days. Speaking in front of me is one of the Senate's most respected members, Lamar Alexander of Tennessee. To my left is Sen. Dick Durbin of Illinois, the Dreamers' greatest advocate. This session was more procedure than substance, but establishing a process is part of getting there. The bad news is that immigration is complicated and tough with strong feelings and powerful politics on both sides. The good news is that I have never seen such intense bipartisan interest and effort on one topic since I've been here (for example, there are about 30 senators in this meeting). Maybe, just maybe, the Senate can actually be the Senate.

Rare View
Washington, D.C.

Now, here's a view of the Capitol you don't see every day—from an underground room in the Visitors Center. Today has, again, been spent mostly talking about DACA (three meetings and innumerable side conversations just today) with a dose of State of the Union anticipation thrown in. I'm writing this shortly before President Trump's speech, so I don't know what to expect. Hope for a positive, inclusive message; we'll see. The fun part for me has been hosting my guest Joyce Maker, a state senator from Washington County. It's been great fun to introduce her to my colleagues and show her around this beautiful place. Got to leave for the speech; wish us (all) luck.

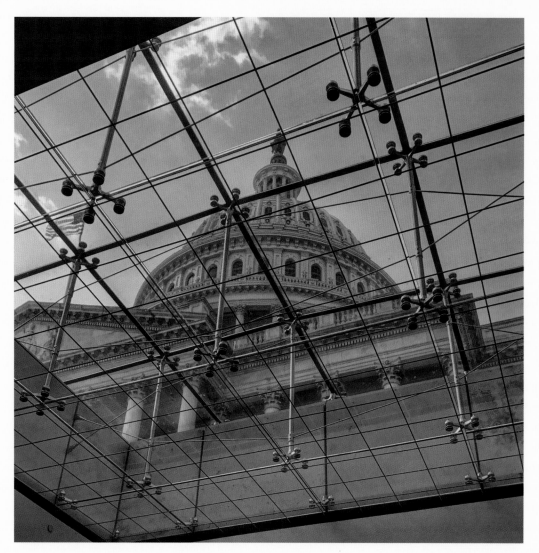

January 30, 2018

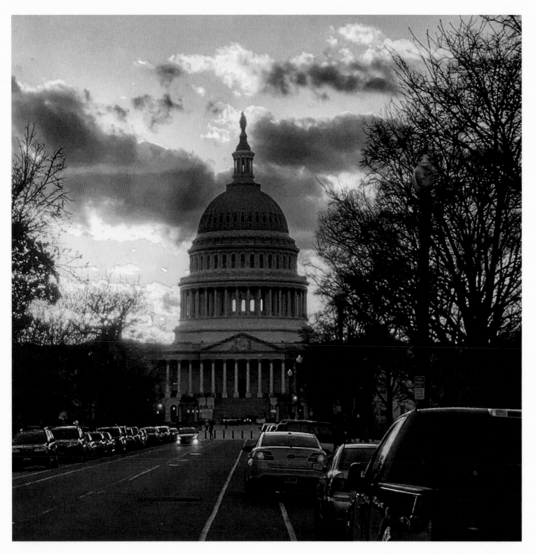

Searching for Tender Shoots of Progress

United States Capitol, Washington, D.C.

Daylight saving time—walking to dinner at about 7:30 and it's still light! This shot is from 2nd Street, looking west down East Capitol Street. There's so much going on (just today), it's hard to know where to start—the Secretary of State was fired (by tweet), the director of the CIA moved to State and the majority on the House Intelligence Committee peremptorily shut down its Russia investigation. And that all happened before lunch. It's hard just to keep up with the pace of events around here now, let alone absorb and make sense of them. But we have to keep at it (the making sense part), and keep looking for progress wherever it raises a tender shoot.

March 13, 2018

Just Talking Helps

Washington, D.C.

How weird is it to post a picture of your dirty dishes? But there's a story here which goes to the heart of a problem with the current barely functional Senate. Air travel and the Senate schedule results in everybody pretty much going home every weekend—even the senators from Wyoming, Nevada or Colorado. This means we don't get to know one another, which leads to a lack of trust and mutual confidence, which in turn makes it near impossible to reach the compromises necessary to get things done. These dishes are the remains of tonight's edition of my personal project to make a dent in this unfortunate reality—a monthly rib dinner for a more or less random group of senators, always relaxed, nonpolitical and especially nonpartisan. Tonight, I had a Republican and two Democrats—and we talked of campaigns, home life, our kids and inevitably how to make the place work better. Not revolutionary, but I'm convinced it's a step in the right direction. At one of our dinners, one of my colleagues pointed to the fellow sitting next to him and said, "You know, I've seen this guy around here for eight years, and this is the first time we've ever talked."

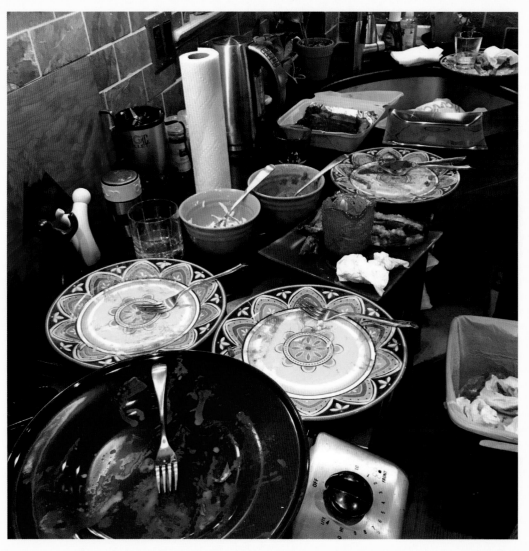

April 23, 2018

May 10, 2018

Don't Make Opponents into Enemies
Washington, D.C.

This is a senatorial three-fer. Sen. Susan Collins and I meeting with eighth-graders from Gray-New Gloucester for questions and a picture. We do this every so often and always get fun questions ("What's the best part of the job?" "Do you have a bodyguard?" or my all-time favorite, "Do you dye your hair?" The answer, by the way, is "no"). It's also fun to share stories with the kids. Today, for example, Susan told of our running against each other for governor in 1994, but maintaining our relationship after that unfortunate result (for her, that is) and now we're close friends and colleagues. The lesson? Don't turn opponents into enemies. And the reason this shot is a three-fer makes the same point—because it was taken and texted to me by my good friend James Lankford, a Republican senator from Oklahoma, who noticed our impromptu seminar while on the way to his office. The lesson from that? Although the atmosphere is too often highly partisan around here, there is still an important place for friendship and mutual respect. In other words, as Susan said, "Don't make opponents into enemies."

Love is Powerful
Washington, D.C.

I knew Bishop Michael Curry when he was just cool; now, after his amazing sermon at the Royal Wedding, the whole world knows he's *way* cool. This morning, the bishop was in Washington to lead Morning Prayer (it's an Episcopal thing) and do a little preaching to a slightly smaller audience (about 40) than he had last Saturday. (I'm proud to say his appearance was on my schedule *before* the big splash at the wedding.) He has a contagious spirit which comes through in every interaction—as you can see here. And he's right—love *is* powerful and we could use more of it, especially these days.

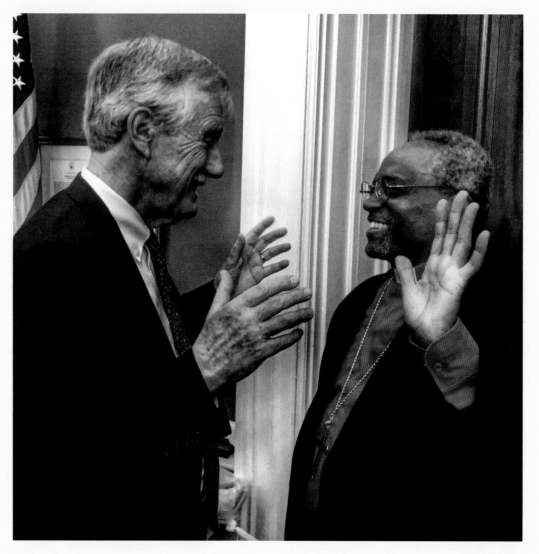

May 24, 2018

On the Road

The day of the congressional "junket" seems to be pretty much over, at least as far as I can tell. My trips have all involved national security —mostly to the Middle East and East Asia—and included a memorable whirlwind with John McCain to Israel, Saudi Arabia, Quatar and the UAE in about six days. The primary subjects were Syria and Iran and included meetings with political, military and intelligence leaders, as well as our own people on the ground. Traveling with McCain is like a long march with Paul McCartney—the pace never slackens and everybody recognizes him. I was the guy the tourist would hand the camera to with the request, "would you mind taking my picture with Senator McCain?"

One of my first trips abroad was to India, Pakistan and Afghanistan to meet with foreign leaders, intelligence professionals and our troops (especially those from Maine). At one of our early meetings with a senior official in Pakistan, his first words were, "I know why you are here." "Oh really, why?," we responded. His answer was profound, "Because one day of seeing is worth thirty days of reading." Over and over, I have found him to be right.

My other trips, of course, are back and forth between Maine and Washington, which allow me to hear firsthand from my constituents about whatever is on their minds—what Lincoln would call a "public opinion bath"—twice a week, PWM to DCA and back. And, yes, I have to go through the TSA line, just like everybody else!

Improving Lives
India

I am in India with my friend Sen. Tim Kaine of Virginia. The drawing on the floor is a map of a slum area (that's the local term used) showing the location of sanitation improvements. None of the houses in the area had running water, but the local women were working with USAID, local government and several nonprofits to bring in water and teach basic sanitation practices. India is a country of immense contrasts, but it was very moving to see change coming through partnership and local leadership.

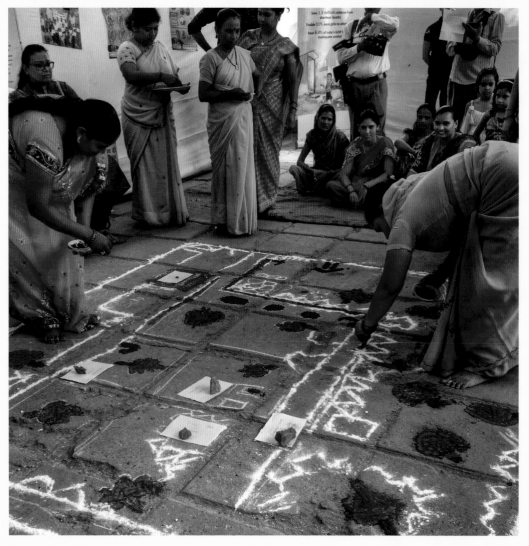

October 8, 2014

View from a Black Hawk
Afghanistan

My view on the way from Kabul to Bagram Air Base via Black Hawk helicopter. My biggest takeaway is what great people we have working for us over here under tough circumstances. Met with everyone from enlisted folks (including half a dozen from Maine) to generals and even the new president of Afghanistan. Can you believe that the first thing President Ashraf Ghani said to me was that he had visited Moosehead Lake—and he had been bitten by mosquitoes!

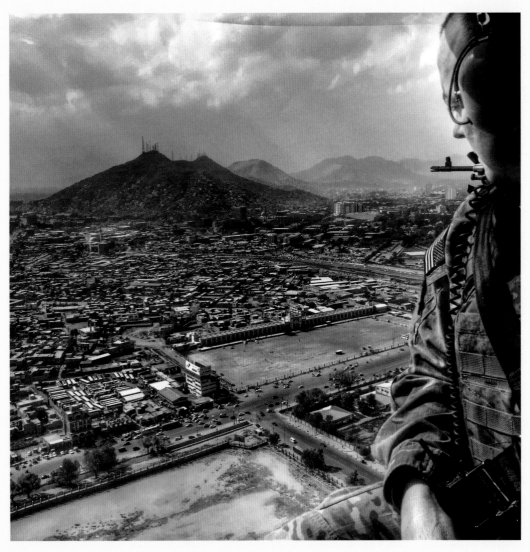

October 12, 2014

TICKETS
STATION/STREET
TRACK 3
TRACK 4

February 5, 2015

Newark Train Station
Newark, N.J.

I stayed home to watch the Super Bowl (definitely one of the best ever, especially if you're a Pats fan) and nothing was flying this morning. So, I am making an all-day train trip to Washington. Here, we are stopped in Newark and I liked the muscular look of the steel frame of the station.

Discussing the World

Somewhere over Alaska

On the way back from the Arctic Conference, Republican Sen. Lisa Murkowski of Alaska and I had an extraordinary two-hour conversation with Secretary of State John Kerry. We literally covered the world—from Syria to Iran to Russia, Ukraine, the Arctic, Yemen, Israel, as well as a little congressional politics. What came through was how complex and dangerous the world is these days and how hard this guy works. It was an extraordinary experience—so much so that I completely forgot I was sitting in that folding chair!

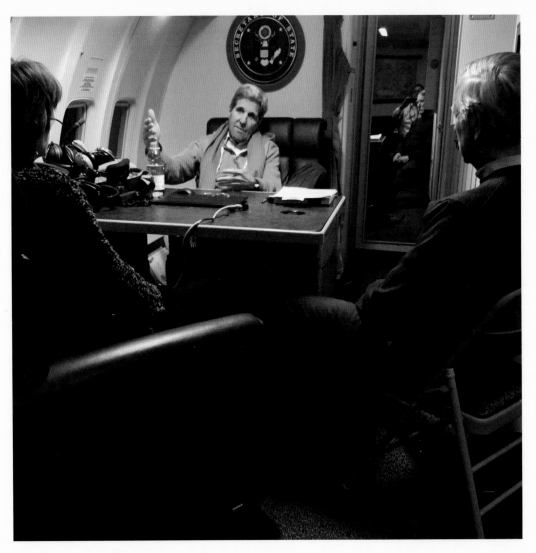

April 25, 2015

Heading Home!
Reagan National Airport

Six a.m. flight home! Left the Senate floor about 2 a.m., got a restful two-hour nap on the couch in my office and made it (barely) to Reagan National. Now, if the connection works in Philadelphia, I'll make it home in time for this morning's Bowdoin College graduation. If the proceedings of the last couple of days looked a little chaotic, well, that's because they were. Boy, am I ready to get back to Maine!

May 23, 2015

From the Vikings to Sustainability

Iceland

Image from a trail in Iceland. Halfway between Europe and North America, the island (about the size of Maine) has 350,000 inhabitants—almost all direct descendants of the Vikings who came here about 1200 years ago. Besides the striking beauty of the countryside, it's pretty cool that virtually all of their energy for heating and electricity comes from hydro and geo-thermal—the hot volcanic rock boiling not so deep underground. Once they get to electric cars, they'll be very close to being the first no-fossil-fuel country on Earth.

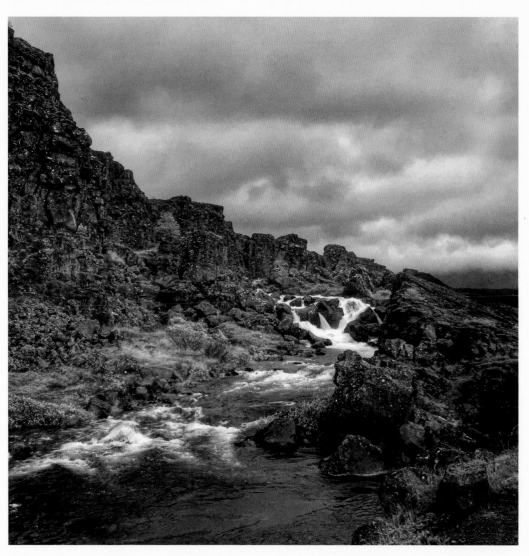

October 17, 2015

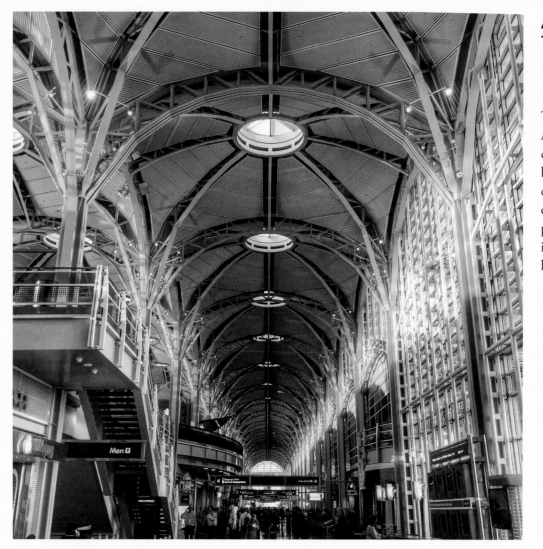

A Cathedral of Transportation
Washington, D.C.

The long corridor in Reagan National Airport is a great public space, a kind of cathedral of transportation. I was struck by the late afternoon sun lighting the columns and vaulted ceiling—a moment of inspiration in the otherwise hectic process of getting to the gate. Sometimes, it's a good idea to slow down and just look up.

November 5, 2015

North to Alaska

Detroit, Michigan

Valentine's Day, Detroit. Temperatures at zero, but also zero wind. Hundreds of vertical smoke plumes look like white feathers stuck in as many stacks. Not cold enough in Maine this weekend, so I'm headed to Alaska! Actually, it's warmer in Alaska, which is part of the reason for the trip—field hearings of the Energy and Natural Resources Committee on energy alternatives for isolated communities, like Maine's islands and a firsthand look at one of the fastest-changing climates in the world. AND Happy Valentine's to my darling Mary; see you on the flip side!

February 14, 2016

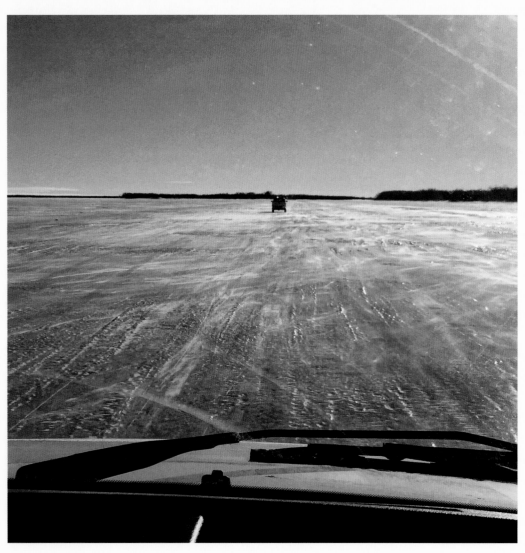

February 20, 2016

Ice Road Trucker
Oscarville, Alaska

How do you get around in Alaska when there's neither road nor airport? Well, in the winter anyway, you drive the river. Here we are on the way to the village of Oscarville (population 90) and a wonderful visit to its school—17 students in grades K-12. Alaska has many such towns and one of their biggest problems is energy—electricity from expensive diesel generators and heat from hand-filled outside oil tanks. Lots of work on this involving solar, small scale wind and batteries. The future is so close, you can almost see it.

Interview at 35,000 Feet

Eastern Europe

What it looks like to do an interview with National Public Radio by satellite phone at 35,000 feet. I have been traveling in eastern and central Europe with five members of the Intelligence Committee since last Thursday night. We started in Poland (Warsaw and Kraków), then went to Ukraine and yesterday to Paris where we woke up to news of the Brussels terrorist attacks. After learning of the attacks, which killed 32 civilians and three perpetrators, we spent the next five hours with U.S. and European intelligence and law enforcement people. A big problem here is lack of coordination between European countries on terrorism—in many ways, they are where we were before 9/11 with intelligence and law enforcement agencies in silos. Enlightening, but sobering trip. Very sobering.

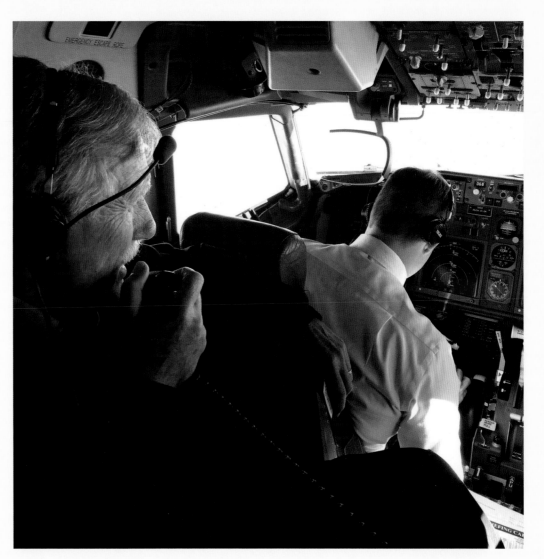

March 23, 2016

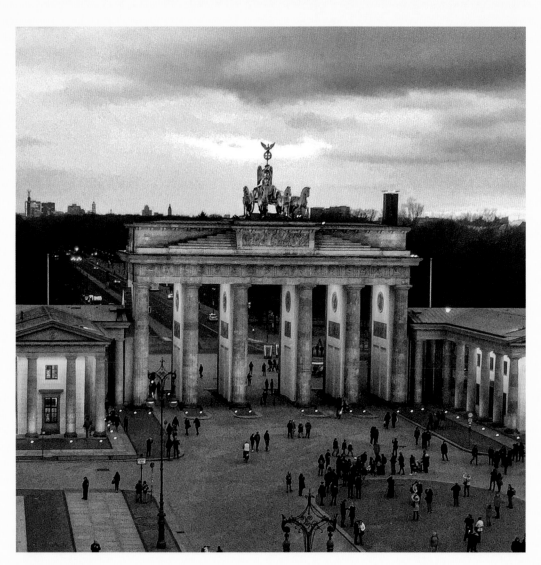

The Brandenburg Gate
Berlin, Germany

The famous Brandenburg Gate in the center of Berlin, looking west. The Berlin Wall, which went right by this spot, divided Berlin for 40 years, but there's not much sign of it now and both sides of the city are full of traffic, shoppers and new construction. Seeing the unified city makes you wonder about all the lives—and precious time—lost in the name of a half-forgotten ideology. No system is good which has to lock its own people in.

March 24, 2016

North of the Arctic Circle

Ilulissat, Greenland

A Greenland sunset, 200 miles north of the Arctic Circle. I am on a trip to the high Arctic with the Commandant of the Coast Guard and a group of scientists to view the extraordinary acceleration of the melting of the ice sheet as well as to look at the national security implications of the opening up of the Arctic Ocean (most of which borders Russia). Awe-inspiring scenery; sobering subjects.

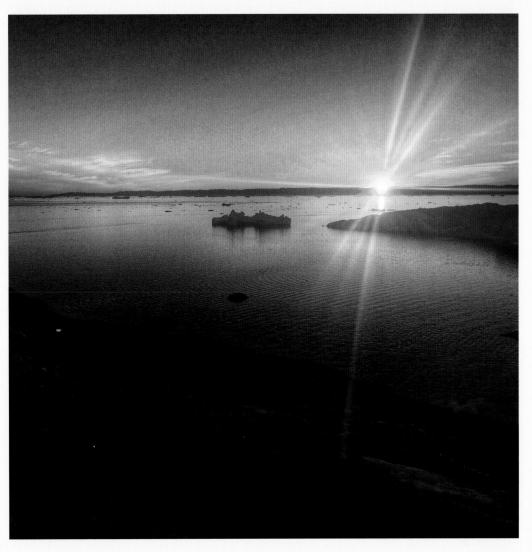

August 22, 2016

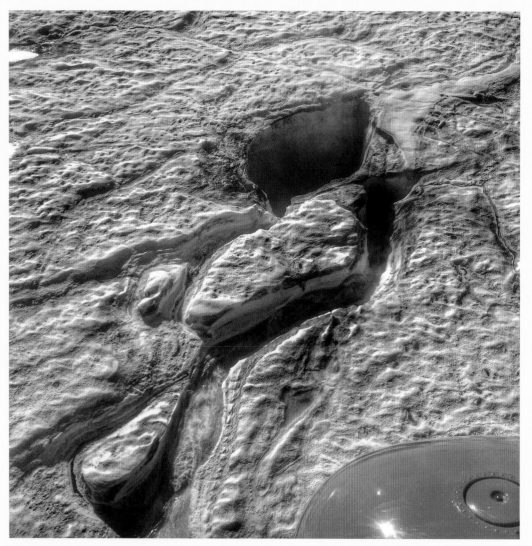

Climate Change
Greenland

There are two ominous aspects of this picture. What we're looking at is called a moulin—a hole in the Greenland ice sheet that goes down thousands of feet to bedrock; as that river of meltwater pours down, it acts as a lubricant under the ice, accelerating the melting and movement of the ice toward the ocean. The second problem is the black-grey color of the ice, which is caused by particles of carbon carried on air currents from around the world that settle on the ice and, again, accelerate melting. As one of the scientists with us said today, the Greenland ice sheet is the elephant in the room of climate change.

August 22, 2016

An Iceberg the Size of Downtown Brunswick

Isfjorden, Ilulissat, Greenland

On the Danish Frigate *Thetis* just outside one of the fjords where the Greenland ice sheet forms glaciers (a literal river of ice), which in turn break into icebergs. The fjord is 6,000 feet deep, but there is a shelf at its mouth that's "only" 600 feet deep, so the big bergs get stuck until they melt or are pushed over the reef by the high winds. The one in front of us is about the size of downtown Brunswick. I think this is about as close as I want to get to one of these monsters, even in a double-hulled warship.

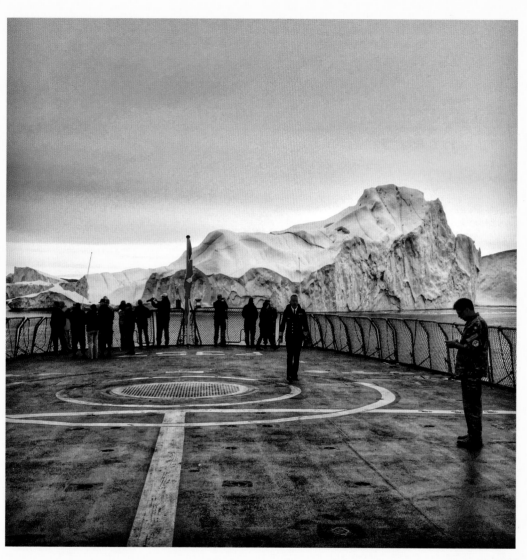

August 23, 2016

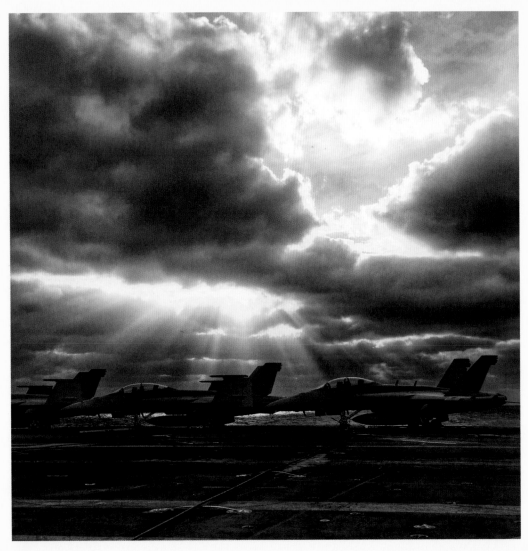

Night Maneuvers
USS George Washington

F18 Hornets on the deck of the USS *George Washington*. The coordination of the landings and takeoffs was amazing with planes being moved in what seemed like all directions and crews readying them for the next flight. What was even more amazing was to see them do it all at night. To land, the pilots must hit a window of a few feet to catch a tripwire, which then slows the plane from more than a hundred miles per hour to zero in (literally) three seconds. Believe me, it's a jolt.

December 4, 2016

Lights at Night, NYC
Manhattan

On the way home Thursday night, I happened to look down—and there was Manhattan, incredibly clear from 35,000 feet. The first feature that jumps out is the dark rectangle of Central Park; I've always been amazed and inspired by the geniuses who set that incredibly valuable piece of real estate aside for a future they could barely envision. Ironically, the other noticeable spot is the circle of lights around Times Square—a perfect counterpoint to the darkened park. What would the scientist Jefferson or the New Yorker Hamilton have given to see this sight?

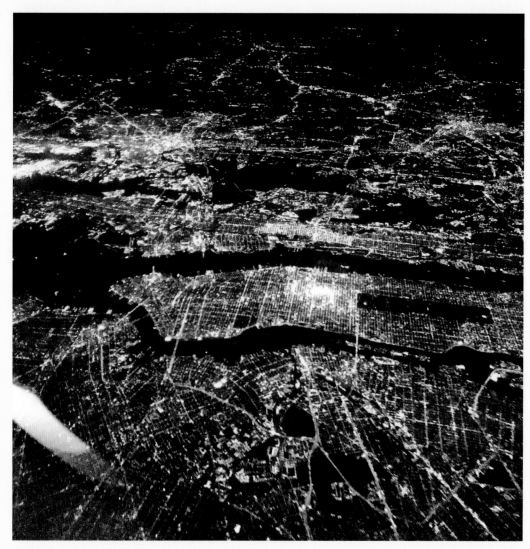

September 7, 2017

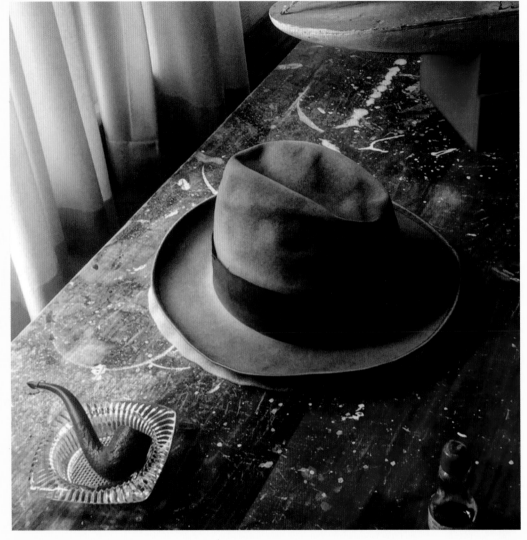

The Spirit of the Roosevelts

Campobello Island, New Brunswick, Canada

Something about Franklin Roosevelt's battered fedora and old pipe touched me as I entered the family cottage at Roosevelt Campobello International Park this afternoon. He left them here on his last visit, in 1939, just before the beginning of the tumultuous events of the next five years. This extraordinary place is on Campobello Island, Canada, just across a short bridge from Lubec, Maine, and is where FDR spent his boyhood summers—and where he was stricken by polio at the age of 39 in 1921. The spirit of Eleanor and Franklin are surely here, and somehow this old hat captured it for me.

September 15, 2017

Back to Work

Portland International Jetport, Portland, Maine

About to be de-iced before taking off from Portland. This is one of those parts of air travel that produces mixed emotions—it slows down the schedule, but beats what might happen if it doesn't get done. Here's to all those unsung heroes (like the guy manning the nozzle on the front of that truck) who help millions of us to get safely home for the holidays. Or in my case, get to work.

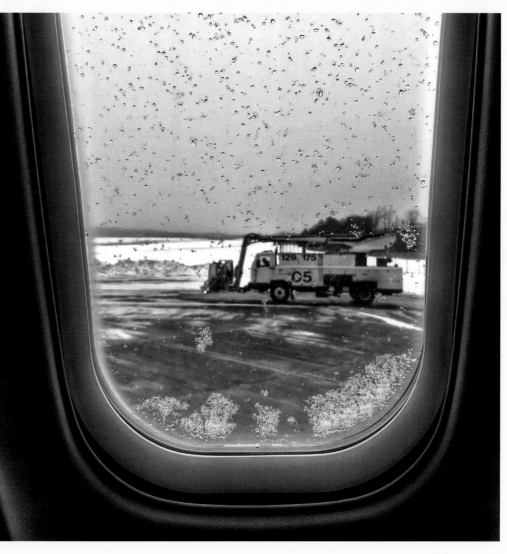

December 18, 2017

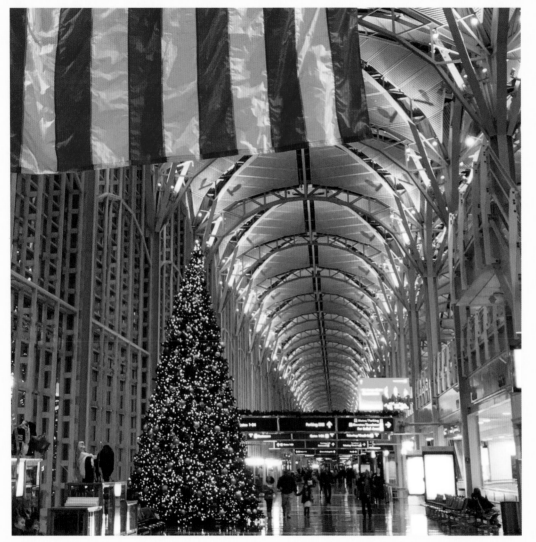

December 21, 2017

Patriotic Christmas at Reagan National

Reagan National Airport, Washington, D.C.

Something about the juxtaposition of the flag and the Christmas tree at the airport caught my eye on the way to the gate. I'm headed home for the holidays and I am sure ready for a strong dose of Maine. This has been a frustrating and tough couple of weeks—hopeful for better next year. Ever hopeful!

Fighting the Good Fight
Washington, D.C.

If there was an anti-tired filter for shots like this, I sure would have used it. As it is, here are yours truly and Doug Jones, the new senator from Alabama at the airport getting ready to head home after 11 days of nonstop sessions and meetings (although I did get to watch the second half of the Patriots-Jacksonville AFC Championship game in the office. Tom Brady and Danny Amendola were in a zone in the fourth quarter, as usual). I told Doug he arrived just in time to see as much bipartisan energy and concentration as I've seen in the past five years. Although we are working in small groups on different aspects of the DACA issue (I'm working with three others on finding a mutually agreeable border security piece), in the end, a successful resolution will largely depend upon the president, as getting something through the House will almost certainly require his blessing. I'm encouraged by what I'm hearing from the White House today (Thursday) about a path to citizenship for Dreamers, but the devil is in the details, which we'll learn in the next few days. In the meantime, I'm really looking forward to a couple of days in Maine!

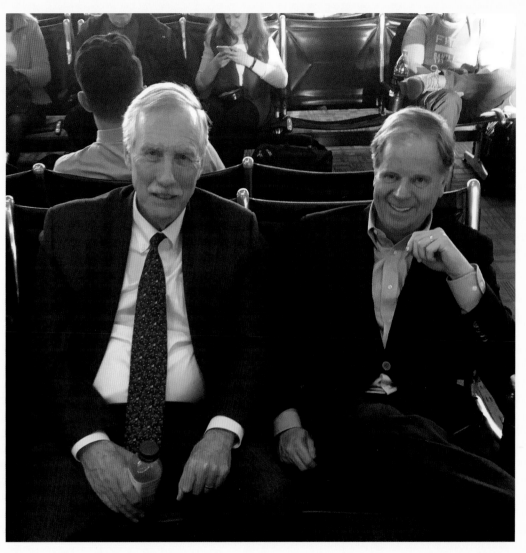

January 25, 2018

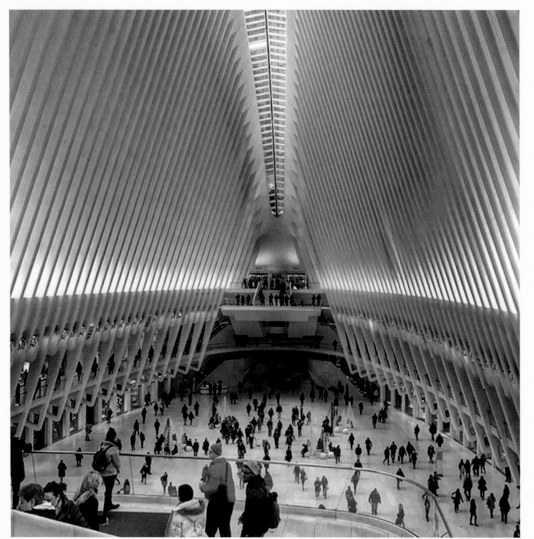

Soaring Design
New York, New York

This is the new subway and PATH station in Lower Manhattan, next to the 9/11 Memorial. The building is as dramatic outside as in, looking like a great white soaring bird. I think it's cool that we still have the imagination and civic courage to build public spaces like this, which are fun and even uplifting—and who knew getting to the subway could ever be uplifting?

March 23, 2018

Sleeping on the Train

Union Station,
Washington, D.C.

Some of the great interior spaces in America are the magnificent train stations of the 19th century. Grand Central in New York, 30th Street in Philadelphia, South Station in Boston, Chicago, Los Angeles and here, Union Station in Washington. Alas, many more were lost to "progress" in the last century, including the great Union Station in Portland. It's an early morning (4:50 to be exact) after a late night finishing up the budget on the Senate floor. Since I only had a couple of hours between the last vote and that 4:50 departure, I decided to sleep in my clothes on the couch in my office, which is only a few blocks from the station. Not too glamorous, but enough to hold me until the next nap—this time on the train. (One of the good things in the budget is support for Amtrak.) Headed to New York for a belated birthday weekend with Mary, then back on the train and north toward home.

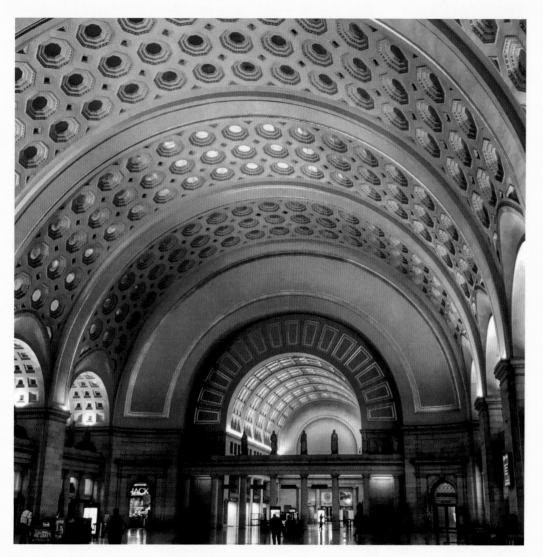

March 23, 2018

Maine Places

Trying to capture the beauty of Maine landscapes and seascapes is often an act of subtraction rather than addition. There's just too much, everywhere you turn. There are few places on Earth with the variety of stunning natural settings, from ocean to forests, to mountains and achingly beautiful inland lakes.

One the reasons for this book and these pictures is that I simply can't not take them, especially when the camera is part of the phone always in my pocket. An ocean sunrise, mist over a lake, fresh snow on a mountainside, all speak of something larger—and more permanent—than ourselves.

Be warned, however—this section of the book is unabashedly subversive and is designed to make those of you "from away" envious, or better yet, transplants.

Reflected Sunset
Millinocket, Maine

Reflected sunset on Millinocket Lake. No need for more words.

September 28, 2014

Warm Memories

Georgetown, Maine

On a snowy day in Maine, it's nice to remember warmer days. Here's a summer evening-reflected sunset on one of the Five Islands in Georgetown. Don't we live in a beautiful place?

November 28, 2014

Visions of Summer
Georgetown, Maine

OK, I don't know about you, but I'm ready for a little dose of summer right about now (and it's not even March!). This is the entrance to the porch at the Grey Havens Inn on the Reid State Park road in Georgetown. A really special place—for a wedding, family reunion or just a quiet dinner on the coast. We're looking across at Southport Island which forms the west side of Boothbay Harbor. I can almost feel the warm summer breeze. Almost.

February 3, 2015

The Grand Strand

Rockland, Maine

One of Maine's gems—the restored Strand Theater in Rockland. Mary and I went to see BeauSoleil, a wonderful zydeco band from Lafayette, Louisiana. The Cajuns of Louisiana are cousins of the Acadians of the St. John Valley in northern Maine.

February 14, 2015

Winter Beauty

Rockport, Maine

Rockport Harbor, Maine, on a winter's day. Fortunately, we got the wind, but not the snow!

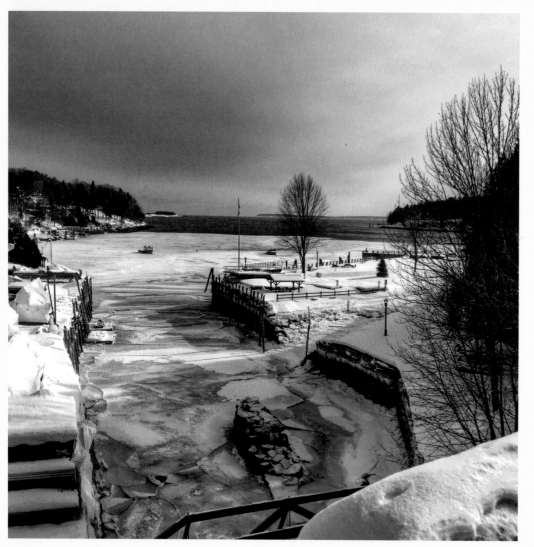

February 15, 2015

America? Thataway!

Rangeley, Maine

Sign at the top of Saddleback Mountain outside of Rangeley, Maine. The trail is called "America"—but I thought the sign in the winter landscape was suggestive of a rugged spirit as well.

February 22, 2015

September 3, 2015

Morning Coffee, Down East Style

Cobscook Bay, Maine

I had a series of meetings in Washington County this week and Mary and I decided to make an RV trip of it. We stayed the first two nights at one of Maine's real gems—Cobscook Bay State Park. Here's Mary enjoying her morning coffee just down the hill from our campsite. She had a day in the park while I visited some cool Maine businesses. Lots going on Down East!

Screw Auger Falls

Grafton Notch State Park, Maine

Screw Auger Falls in Grafton Notch State Park. One of the nice things about this beautiful spot is that it's only about 50 feet off the road—and is accessible to pretty much everyone. While we were there, some older folks (even older than us!) and a young man in a wheelchair came in to enjoy a spectacular Maine day. The park is about five miles north of the entrance to Sunday River just off Route 2. If you're up that way, it's well worth the side trip!

October 10, 2015

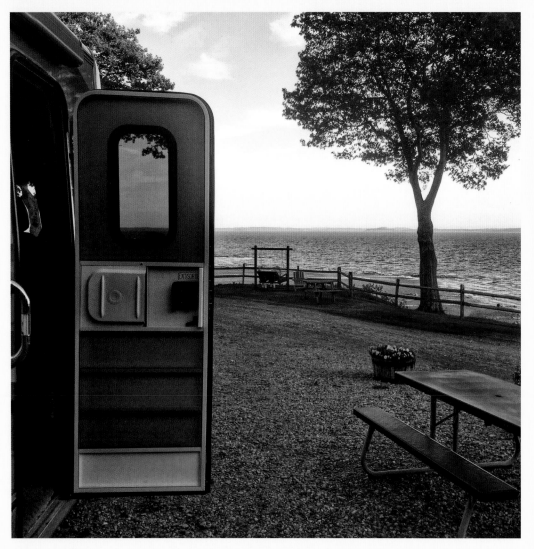

A Night on the Coast
Belfast, Maine

Mary and I decided to do some Maine RVing over the long weekend and after two days in the Western Mountains ended up on the coast—Belfast, to be exact. Everybody involved with tourism tells me that they've had a great summer, and that it's still going on. Meanwhile, how's this for a spot to set up for the night?

October 12, 2015

Christening the *Rafael Peralta*

Bath, Maine

Speakers-eye view of the christening of the Destroyer *Rafael Peralta* at Bath Iron Works, with the in-process hull of one of the new Zumwalt class ships in the background. These ceremonies are always moving, and especially so in this case, because of Sgt. Peralta's extraordinary bravery in sacrificing his life for his fellow Marines during a firefight in Iraq in 2004. Hopefully, these ships will never see combat because their very existence is intended to deter potential adversaries.

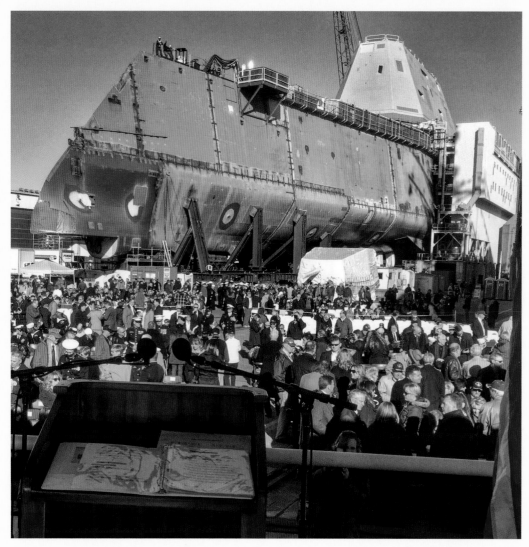

October 31, 2015

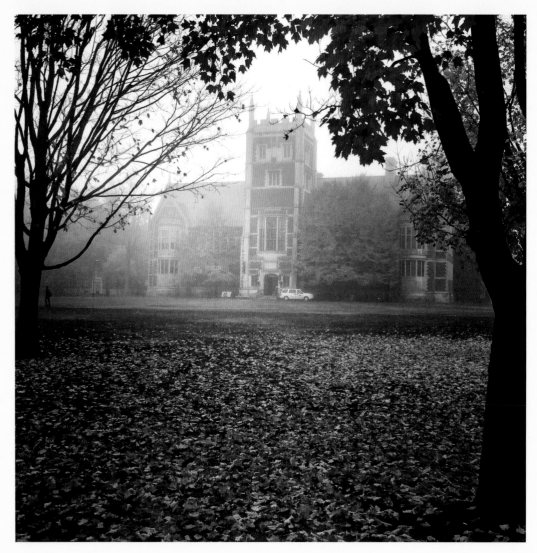

Shrouded in Fog

*Bowdoin College,
Brunswick, Maine*

Early morning fog in Brunswick. This is Hubbard Hall at the south end of the Bowdoin College quad. A passing student, undoubtedly from out-of-state, pronounced the fog "creepy," repositioned his earbuds and hurried off to class. I think it's kind of cool.

November 6, 2015

Dreamlike Frosting
Maine

"The Berkshires seemed dreamlike on account of that frosting." This isn't actually the Berkshires that James Taylor sang about, but the road to Bangor. And it is the ideal snowstorm—frosting the trees but not the road.

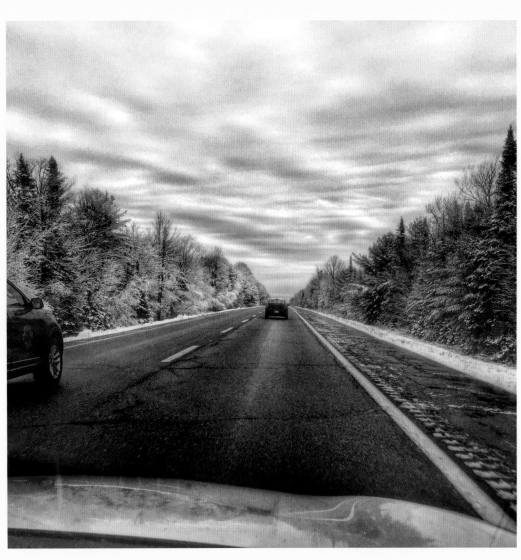

November 23, 2015

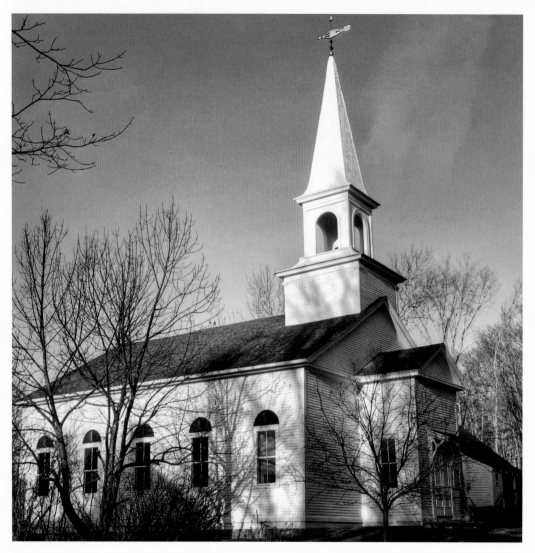

November 25, 2015

Classic New England Chapel

Woolwich, Maine

One of Maine's special places (and there are a lot) is the village of Days Ferry just up the Kennebec River from Bath. You have to journey off Route 1 for a couple of miles, but it's worth the detour. I was struck by this classic New England chapel a few yards from the village center. Seems like a nice visual to accompany warmest Thanksgiving wishes from my family to yours!

Above the Clouds
Carrabassett Valley, Maine

This is *not* a shot taken along the Maine coast—rather it's from the top of Sugarloaf this morning. Yes, above the clouds! The "island" in the background is actually the ridge of Mount Bigelow. Never saw anything like this before; Maine always has something cool in store. Friend Dan Bialosky got the shot.

December 24, 2015

Crisp Air, Blue Skies
Bath, Maine

Saturday morning was one of those special Maine moments—brilliant sun, crisp air and impossibly blue skies. This shot of downtown Bath is looking eastward toward City Hall at the top of the hill. How can you not love this place?

February 28, 2016

Speak of Peace and Aspiration

Brunswick, Maine

First Parish Church in Brunswick normally has two spotlights at the base of the tower, but on this evening, only one was lit. The church is a wonderful example of a 19th century architectural style called Carpenter Gothic—the evocation of the great European cathedrals in wood. The architect was Richard Upjohn, who also designed my church, St. Paul's in Brunswick, as well as many others all the way down to Virginia. I love to stumble upon illuminated churches in Maine's small towns; they speak of peace and aspiration for something which transcends.

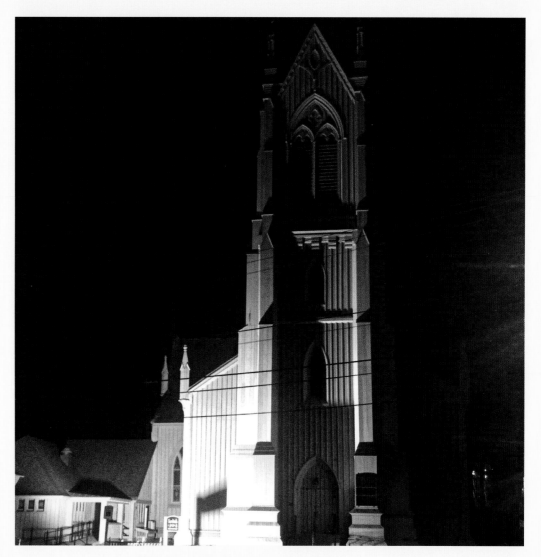

April 10, 2016

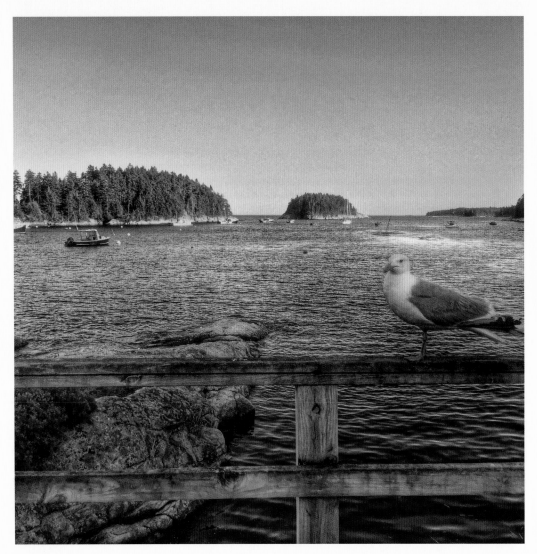

Five Islands

Georgetown, Maine

I could swear this gull was posing, but more likely, he's after our fries. This is the Five Islands Lobster Company wharf in Georgetown, home of the Big Boy, a truly massive lobster roll. The setting is absolutely amazing—it looks like it was invented for a movie. And the food is great, too.

North Atlantic Blues Festival

Rockland, Maine

A beautiful July evening on the waterfront in Rockland. The town is packed for the Blues Festival which features acts on the stage on the waterfront all day and bands (many local) along the street at night. Good to be back in Maine.

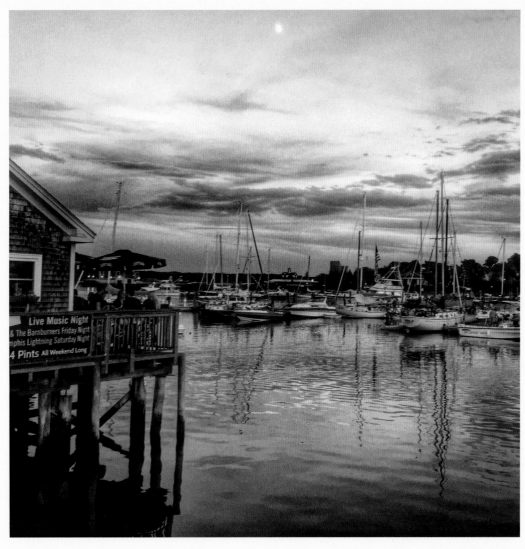

July 16, 2016

Traveling Along a County Road
Aroostook County, Maine

Aroostook County! Heading upcountry for a couple of days to visit farms and businesses. There's something very special about these rolling hills and open skies. If you're from southern Maine (or out of state), visiting The County is a completely different experience than visiting the coast or mountains. And great people as well.

July 26, 2016

Day's End
Georgetown, Maine

Just another beautiful Maine sunset. We need rain, but it sure has been a wonderful string of summer days.

August 8, 2016

September 16, 2016

Island Journey
North Haven, Maine

On the ferry to North Haven Island to attend a surprise birthday party for our old (young) friend, Christie Hallowell. This image is looking back toward Rockland from the entrance to the Fox Island Thorofare. One more spectacular evening in Maine!

Looking East toward Rangeley Lake

Oquossoc, Maine

This is the reward for hiking up Bald Mountain in Oquossoc—a 360-degree view, including this look at Rangeley Lake to the east. This trail is one of many examples of the extraordinary work done in the region by the Rangeley Lakes Heritage Trust—what an amazing gift for generations to come.

October 5, 2016

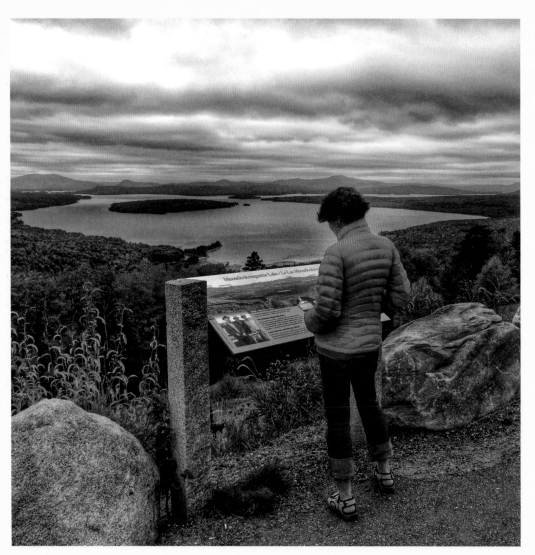

You Are Here

*Mooselookmeguntic Lake,
Rangeley, Maine*

Mary checking out the amazing view from
the Height of Land just south of Rangeley.

October 6, 2016

Winter Solstice

Portland, Maine

Fore Street in Portland on a winter morning—but each day from here on out will be a little longer!

December 22, 2016

January 13, 2017

Along the Watchtower
Naples, Maine

Causeway Marina in Naples (Maine, of course!) on a bluebird day. One of the real joys of my job is exploring Maine on the way to tours and meetings. Great meeting this morning at Bridgton Hospital about its exceptional work on opioid treatment and the staff's serious concerns about the precipitous repeal of the Affordable Care Act. I don't get the rush; let's see what its replacement looks like before we jump off the cliff of repeal.

The Pejepscot Mill

Topsham, Maine

This is one of my favorite buildings in Maine—the old Pejepscot Mill in Topsham —catching the setting sun. Built in 1868, the mill is the oldest surviving paper mill building in Maine—and its perfect proportions are a testament to the eye of the long-lost architect. It now is host to offices and the estimable Sea Dog Brewing Company, and its beautiful south façade greets us local folk every time we cross the "green bridge" from Brunswick.

March 20, 2017

Sense of Community

Islesboro Ferry,
Islesboro, Maine

How's this for an iconic Maine view? This is the light at the ferry terminal on Islesboro shot from the bridge of the *Margaret Chase Smith* (the name of the state ferry that serves the island) as we were heading into the dock. I'm on-island (as they say) for the high school graduation, which was fabulous. There were seven graduates, supported by what looked like the whole town. Alumni in the band and the chorus, parents, grand-parents, summer people—all were there lending an extraordinary sense of real community. And after the week I just had in Washington, spending the afternoon on a beautiful Maine island was truly Finest Kind.

June 11, 2017

Connected to the Sea

Georgetown, Maine

You can see Seguin Island in the distance at the end of a soft summer day. There's something deep within us that connects to the sea, especially at moments like this.

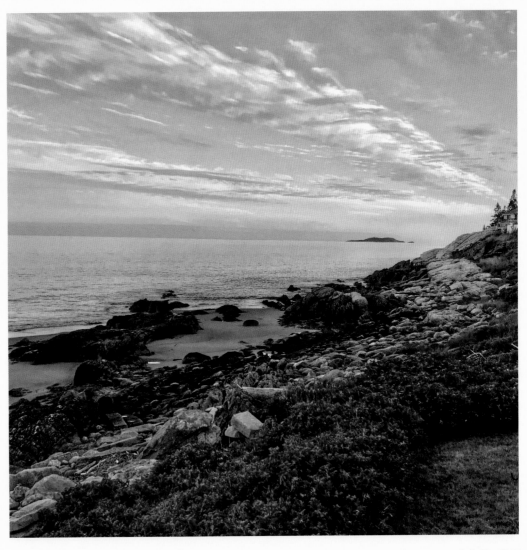

July 29, 2017

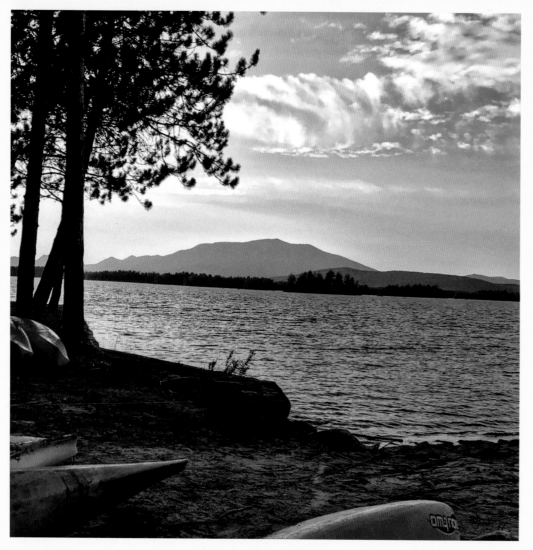

'In All Its Glory'
Millinocket Lake, Maine

"Man is born to die, his works are short-lived. Buildings crumble, monuments decay, wealth vanishes. But Katahdin, in all its glory, forever shall remain the mountain of the people of Maine"—Percival Proctor Baxter. One of the great acts of personal generosity in our history, Gov. Baxter's gift continues to enrich all who visit this spectacular area. I noticed years ago that every Maine governor has a portrait in the State House (the Capitol building to those not from New England), but only one has a statue—Percival Baxter. By the way, he tried to get the Legislature to buy the mountain when he was governor, but it refused—so he spent the rest of his life painstakingly assembling the land which is now his namesake park—by himself.

Beach Day

Georgetown, Maine

Perfect beach day in Maine. This is the south end of Reid State Park in Georgetown. Like Baxter, this magnificent place represents an extraordinary act of personal philanthropy, in this case by Walter E. Reid of Georgetown, who gave the 770-acre parcel to the people of Maine in 1946. What a day; what a gift!

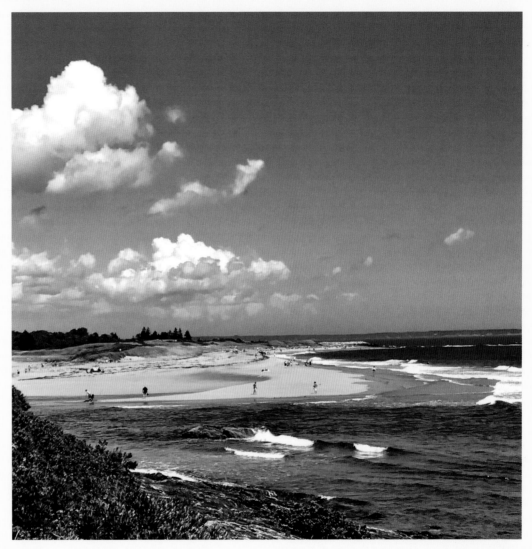

August 13, 2017

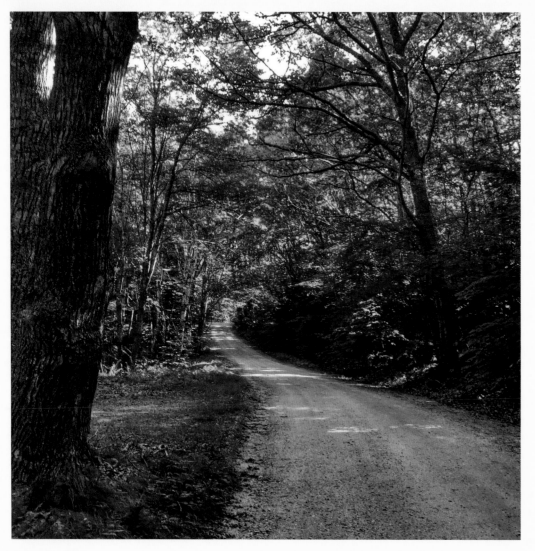

Shhh, This is Our Secret

Country Road, Maine

Early morning on a Maine country road. Summer lingers, but cool mornings are a portent. Remember, however, September is our secret.

August 28, 2017

Quiet Beauty

Greenville

Most visitors to Maine only see the coast, which is, after all, one of the most beautiful places on earth. *But,* venture a few hours inland, and you get this. We spent the night in Greenville on the southern margin of Moosehead Lake, and this is the view we woke up to, made all the more vivid by the fall colors. The one thing I can't convey in this shot is the quiet; an occasional bird cry and slight breeze in the trees, but otherwise a silence we simply don't experience in town. What a place; what a state!

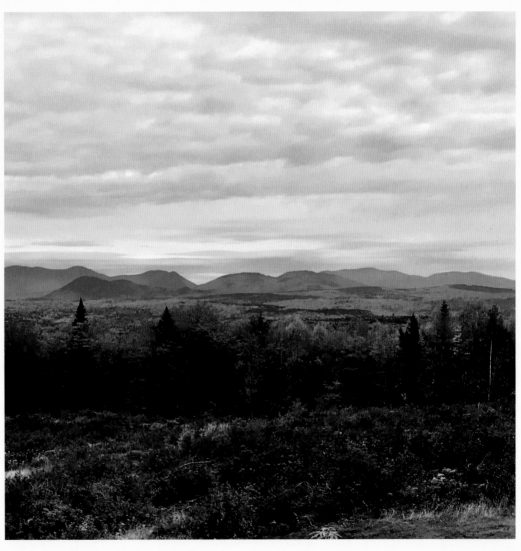

October 9, 2017

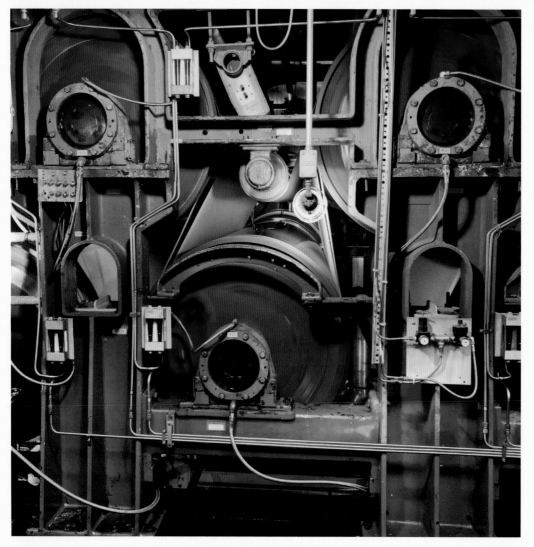

An Economic Catalyst

Catalyst Paper Mill, Rumford, Maine

This struck me as a classic industrial image —a small segment of one of the paper machines at the Catalyst Paper mill in Rumford. More than 100 years old, this mill is one of the mainstays of the Western Maine economy and is undergoing constant reinvention as the paper market evolves. Great people doing hard work— paper is still important for the local community, and for Maine.

October 12, 2017

Morning Mist

Oquossoc, Maine

We visited Bald Mountain Camps in Oquossoc (suburban Rangeley!) a couple of weeks ago and this is the early morning view across the lake as the mist was rising. Maine has countless extraordinary places, and this is sure one of them. Thanks, Steve!

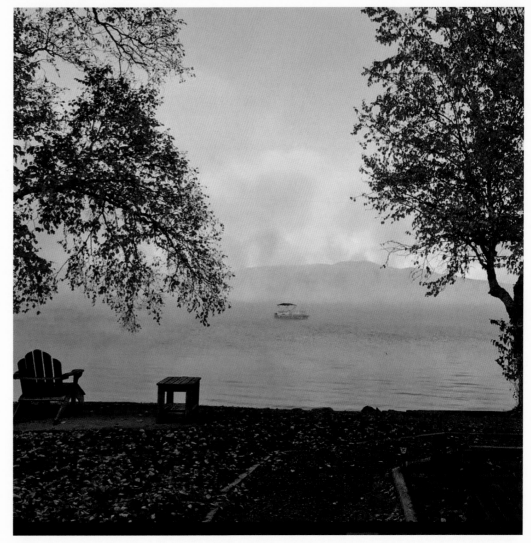

October 29, 2017

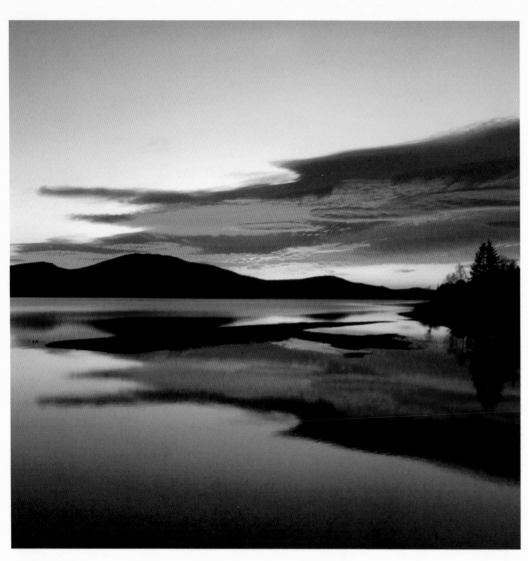

Rangeley Sunrise

Rangeley, Maine

October sunrise near Rangeley. My son (who refers to himself as "the Angus King who was born in Maine") caught this shot Saturday morning and, believe it or not, here it is with no filters or other photo jiggery-pokery. We could use more of these calm moments, especially these days. Thanks, kid.

October 29, 2017

The Port City

Portland, Maine

Nice view of downtown Portland flying in over the islands this morning. The sun is on the east windows of the Pierce Atwood building on the pier, and the Holiday Inn can be seen in the center left. Always great to be home, especially after a late night in Washington. Unexpectedly, I ended up responding on the Senate floor last night to Sens. Rand Paul of Kentucky and Mike Lee of Utah who were complaining about the deficit effect of the budget bill and the process by which we got there. They made some good points, except, they both voted for the massive tax bill less than two months ago, which will have an even greater deficit effect and went through a far worse process. I hadn't intended to speak, but the idea that it's perfectly OK to give massive tax breaks to large corporations and suddenly not OK to fund community health centers and opioid treatment just stuck in my craw. Even had one of my Republican colleagues thank me afterwards—and besides, somebody had to say it.

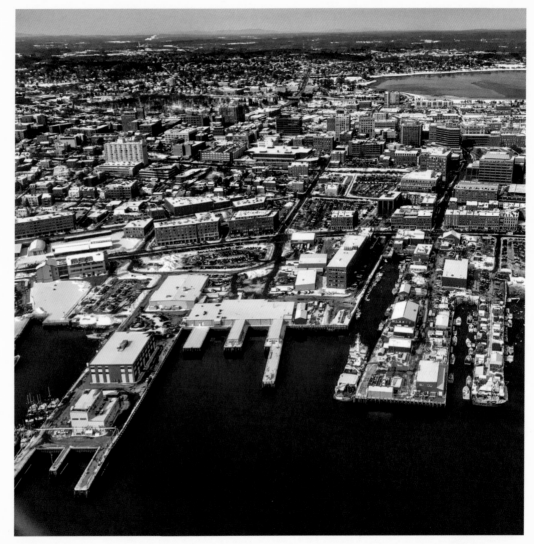

February 9, 2018

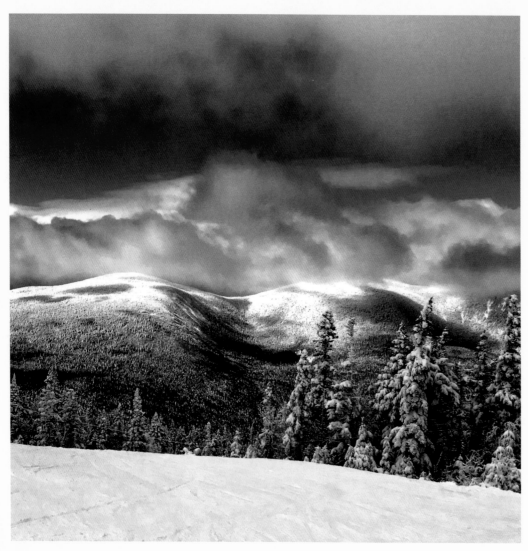

A Bluebird Day
Carrabassett Valley, Maine

The high peaks of the Western Mountains on a cold, clear winter's day. I'll put the variety and beauty of Maine up against just about anywhere else.

March 12, 2018

Loon Lodge

Rangeley, Maine

How's this for a hunker-down spot on a blustery April 1 afternoon? Here is Mary catching up on old magazines in the living room at Loon Lodge just east of Rangeley. It's between seasons here—snowmobiling is winding down, but the lakes are still ice-covered. It's pretty quiet in town, but we still managed some shopping and good meals at the Loon's pub and at The Red Onion and brunch at Bald Mountain Camps. In a couple of months (more like six weeks actually), ice will be out, the boat yards open, trout season—which starts today!—will be well underway and the region will host thousands of visitors and the part-time locals who own camps and cottages up and down the lake shores. It's no wonder people have been coming to this extraordinary place for 150 years. As for me, I just realized we've traveled here by motorcycle, snow machine, RV and a variety of cars—but whatever the vehicle required, we'll be back.

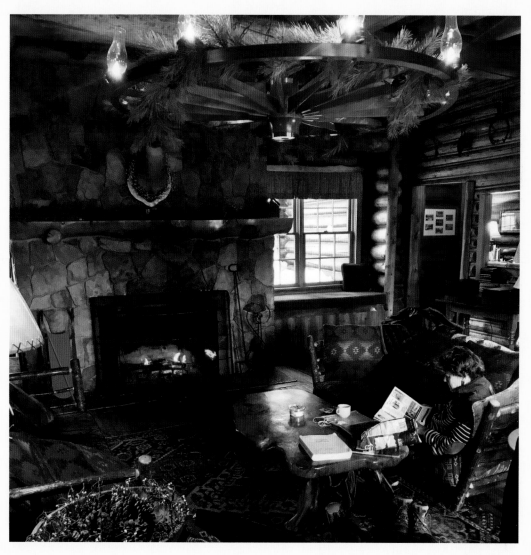

April 1, 2018

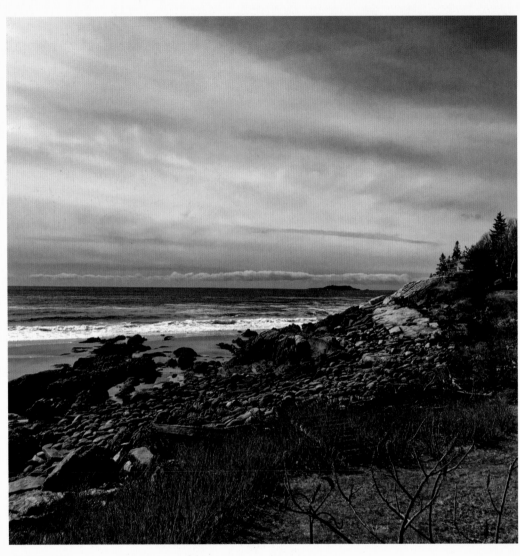

April 7, 2018

The Secret, of Course, is Perseverance

Georgetown, Maine

On my way back to Washington, but I wanted to get a dose of the Maine coast first—a kind of mental fortification. This is in Georgetown, just south of Reid State Park, looking toward Seguin Island on the horizon. Watching the waves, I suddenly had a thought about a lesson they were teaching. The rocks in the foreground are very hard, right? And the water coming ashore in those waves is very soft. And yet, eventually (that's the key word), the waves will win—and those rocks will be reduced to smaller and smaller pieces, and finally, into sand. The secret, of course, is perseverance. The waves just keep on coming, and despite the mismatch, will ultimately grind down the toughest piece of granite. So when you get discouraged, remember those fragile waves—and keep on coming!

One Final Sunset

Brunswick, Maine

Brunswick on a Sunday evening. I've always liked reflected sunsets and this one lit up the Tondreau Block and the eastern sky just as Mary and I were sitting down across the street for a late supper. No profound thoughts tonight, just counting blessings.

So long and thanks for reading.

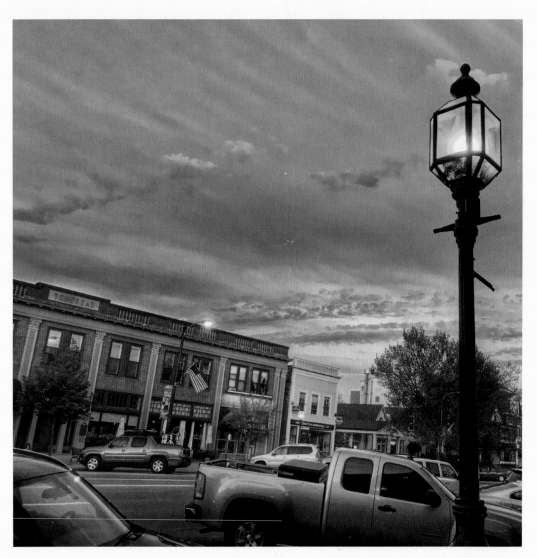

May 20, 2018